Portrait

a photojournal of UB40 on tour

Faith Isiakpere

Fairline

In April 1984, UB40 invited me to accompany them on their Spring Tour of Europe. This book is an account of that tour.

Faith Isiakpere

Editor
Faith Isiakpere

Photographs
Faith Isiakpere
Jim Rowland

Design
Jim Rowland

Thanks to
UB40 Organisation
Christine Keeler
Marjorie Talbot
Jillian Burgess
Sally Rowland
Ellen Dudson
Tony Key
and
Suzanne North

Published by Fairline Ltd.
Alveston House 159 Herbert Road
London SE18 3QE

©Copyright 1984 Fairline Ltd.

Printed in Great Britain by Masterprint Ltd Charlton London

ISBN 0 9510015 0 7

Contents

Intro

"We'd all danced too much and got our clothes all sweaty but who cared! All we cared about was the fact that it had happened and UB40's music made it happen."

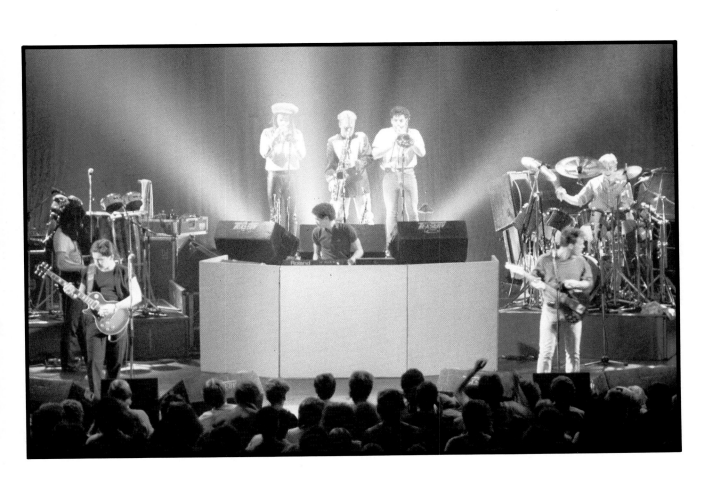

We're a Reggae band, but it's not Jamaican Reggae. Our Reggae is typically British because of the influences. The Jamaican Reggae that you hear in Britain is made by Jamaican artists and the music is now principally rasta music. The British public cannot relate to it. They can't understand the whole rasta way of thinking. What they do understand, they can't relate to.

Jamaican Reggae seems to be too narrow for them. English people relate more readily to our brand of Reggae than they would to Jamaican Reggae, because of the lack of mysticism in our music.

What we write about, sing about and look like is typically very British.

Being a multi-racial group, we're an example of British youth. There's nothing weird about us when the audience sees us. We're perfectly acceptable to the vast majority of Radio One listeners. They don't think of us as a Reggae band, nor do they think of us as vaguely Jamaican. To them, we're just another pop group. Lyrically they can relate to what we're saying. Many young people especially can understand what we're saying and can relate to the lyrics but not necessarily the message.

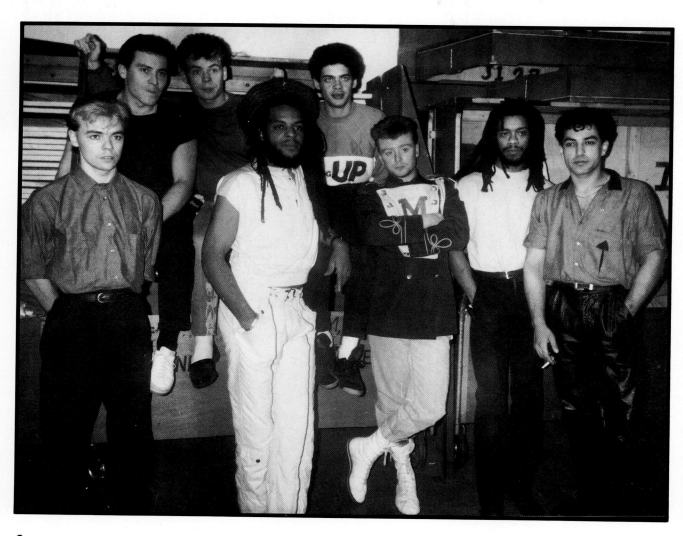

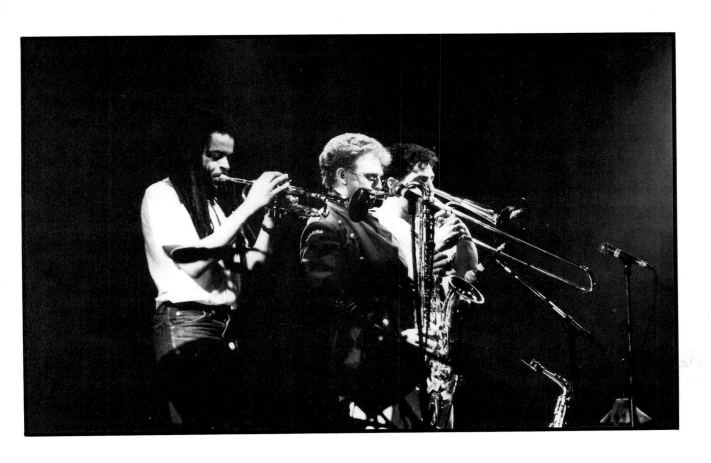

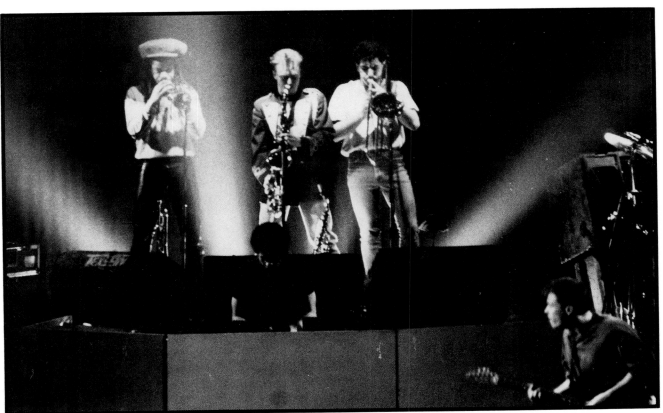

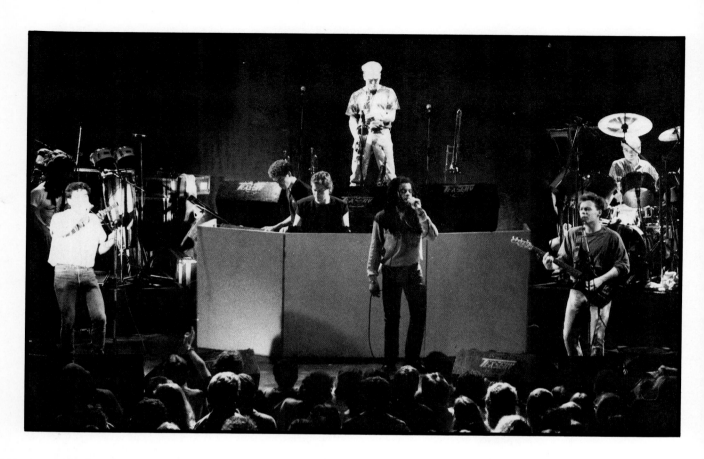

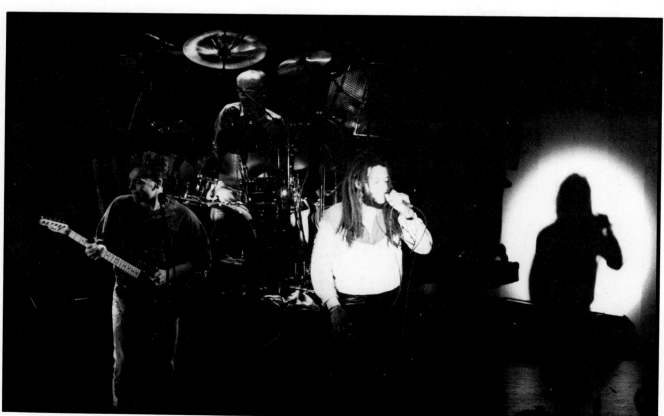

8

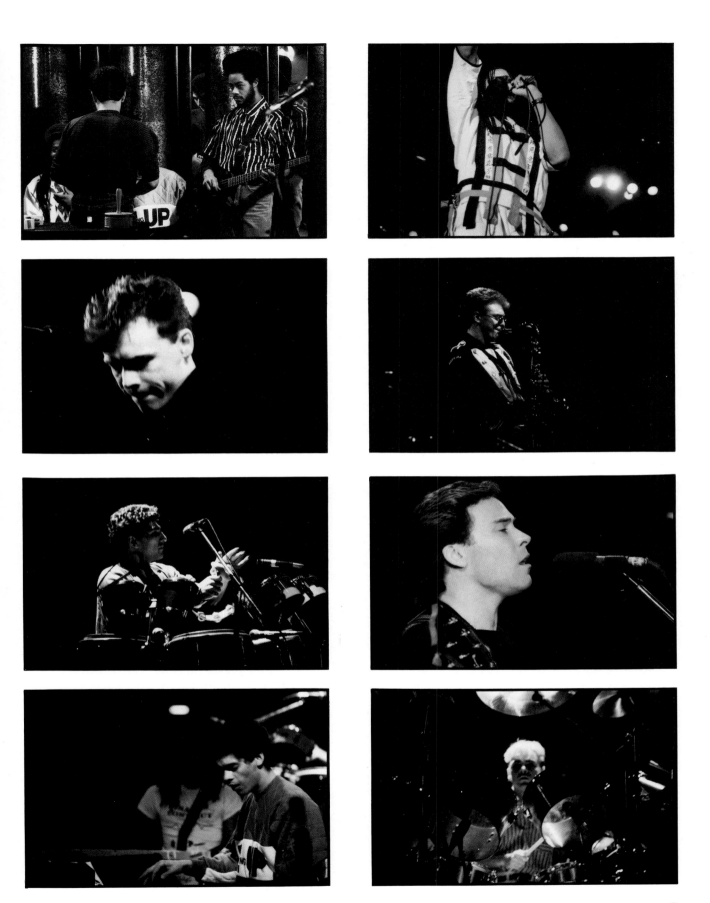

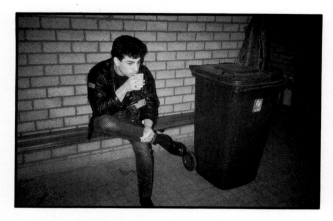

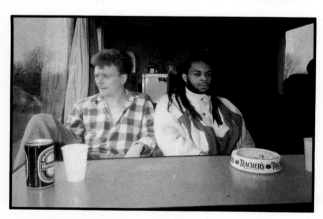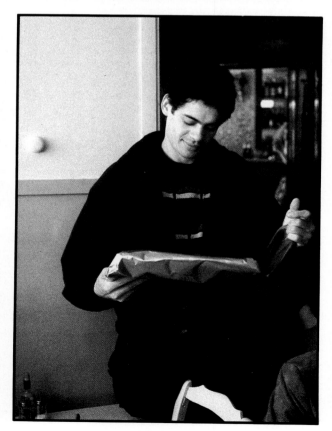

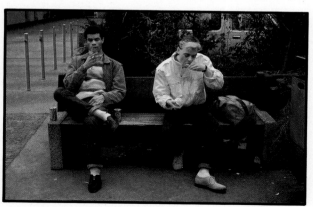

10

In the early days, although our audiences were mainly white, it developed in such a way that more and more black people came to our shows as time went on. Today, we are very proud of being the only pop group whose followers have managed to integrate themselves. We've never had any fights or hassle at any of our shows.

When the Two Tone era started, it brought black and white youths together, but at that time some bands used to use fight sequences as part of their stage act. This inevitably developed feelings which soon erupted within the crowd that went to see them. What started to happen was that many youths went to these shows with the intention of getting involved in a fight, before the evening was over.

Seeing the eight of us take the stage, seems to give the audience a positive feeling of youth working together and there seems to be something positive about us even before we play a note.

At the beginning of each Tour, a Set is decided upon. There are times when different band members will become bored with certain numbers in a Set and wish that they could do a jam session instead, just to get a bit of spontaneity going, but professionalism restricts us and we normally always end up playing the Set as originally planned. There have been times when the order of numbers have been rearranged within a Set, but only on very rare occasions.

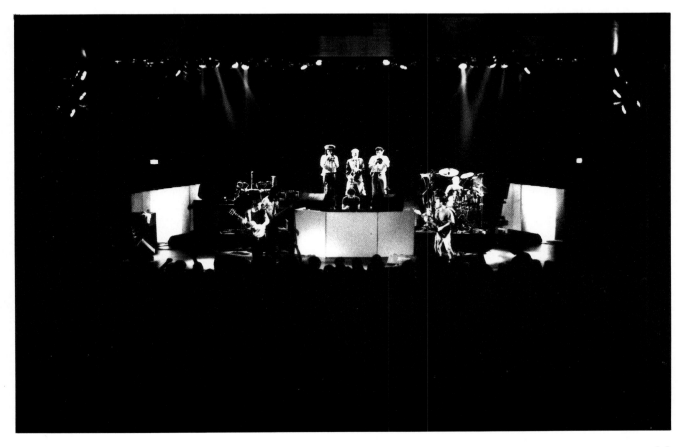

Setting Off

Whether to Australia, New Zealand, USA, Canada or Europe, Moseley, in the heart of Birmingham is the launching point for all UB40 tours.

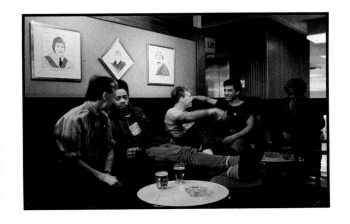

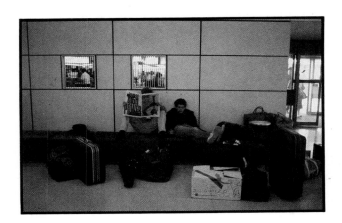

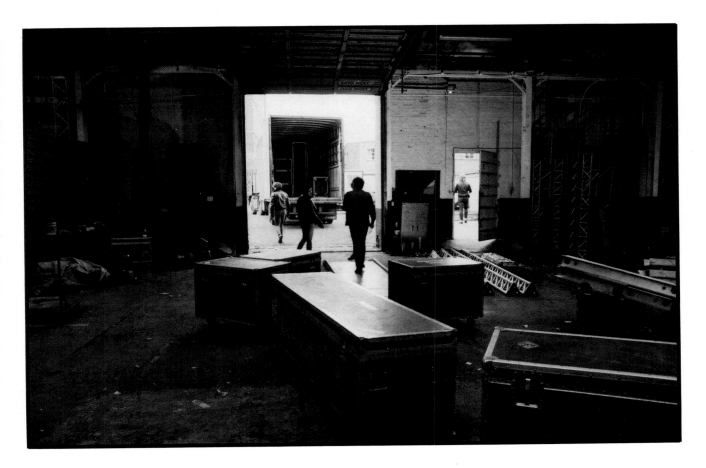

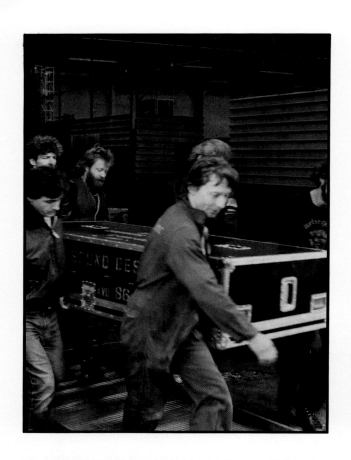

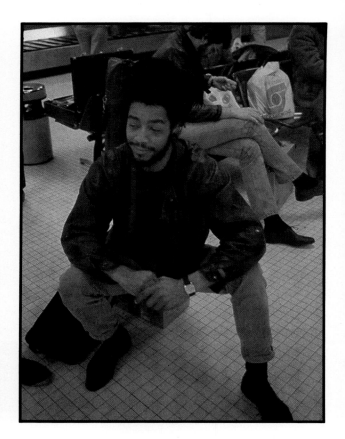

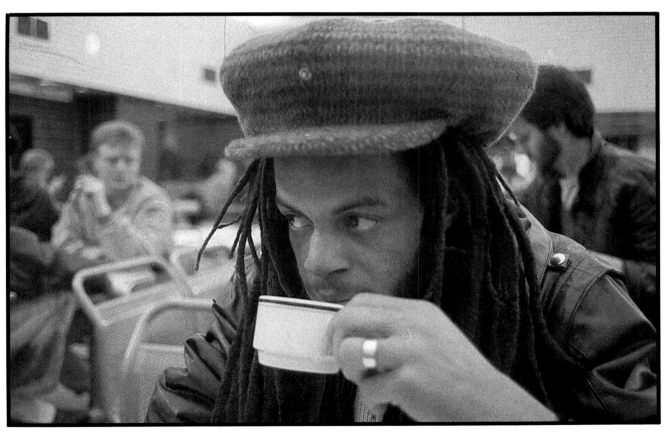

Jimmy

I suppose if I were to spend six or eight hours a day behind my drums playing and trying to get better and better all the time, in a couple of decades I'd be as good as maybe one of the best drummers in the world, but I can't. There are a lot of things I'd much rather be doing eight hours a day.

Before each show, I can get very nervous, so nervous that I'd sooner die than go on stage. To tell you the truth, I do get scared, even now after having done it for so long. Why do I get scared? Well because I am insecure. I am frightened of failing. I don't seem to have enough confidence and I see myself as inexperienced. I think we all are. Sometimes we get through shows by the skin of our teeth.

I enjoy being on tour. I enjoy being in a different place every other night. I enjoy being in different hotels and meeting different people. I like the life, not because it is over the top but just the chance of meeting people. I don't take drugs and I don't drink but I like the girls. The glamour side of it, the idea of being a jet-setter does not appeal to me but the idea of travelling does.

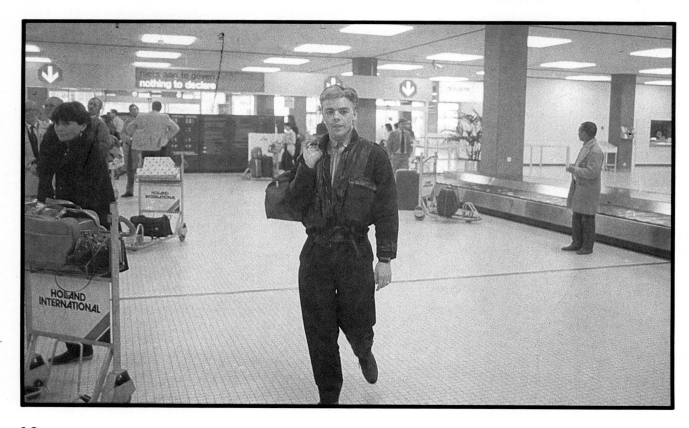

Before going on stage, I go really quiet, I sit in a corner and I have the habit of constantly yawning. I blame it all on nerves. Then all of a sudden I come alive. Sometimes you can actually be nervous on stage. This is a horrible feeling and it is the worst thing that can happen - being nervous while playing. Sometimes you think "I can't do this" and then you make mistakes because you are concentrating too much on your playing. You've got to be able to do it by reflex and not think about what you are doing, because if you are thinking about it, it goes wrong. You have to do things by reaction. When things get out of hand, you can lift yourself up, but sometimes you can also end up giving a bad performance. Most of the time, you hope the rest of the band will carry you or that you will snap out of it. The worst thing that has ever happened to me was to have fainted whilst playing. I passed out on stage, blacked out completely for a few seconds and came round again still playing.

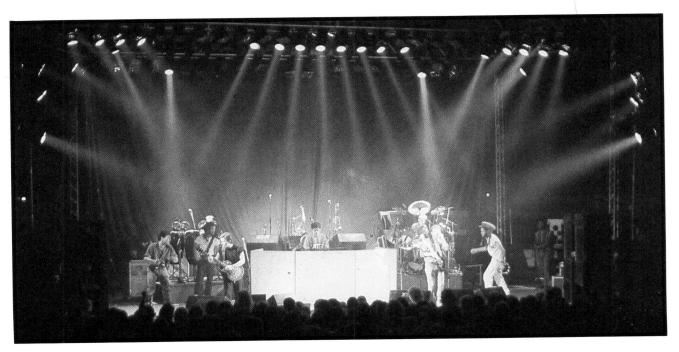

 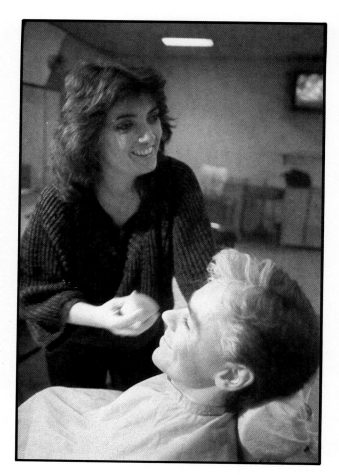

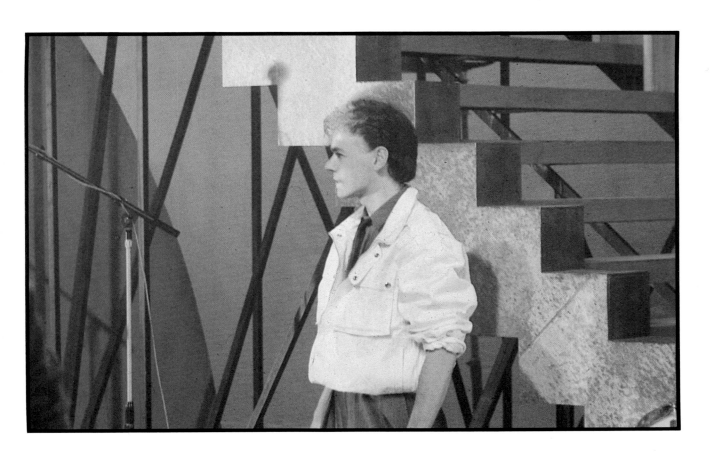

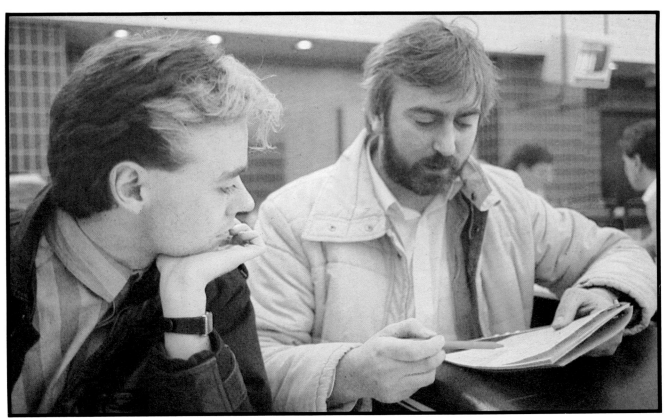

As a drummer, I am the timekeeper. This is a big responsibility because if anything goes wrong you get blamed automatically. If anybody criticises, I shout back and blame somebody else. That's a way of defending yourself. But you do automatically become defensive when people blame you because you know that a lot of the time it is your fault. It's not easy to admit.

I feel the responsibility sometimes is too much. If it was up to me I'd be a percussionist. With the responsibility of being a drummer you don't get any of the buzz that you get by being a front man, and you have to rely on your own resources to pull yourself through a lot of the time.

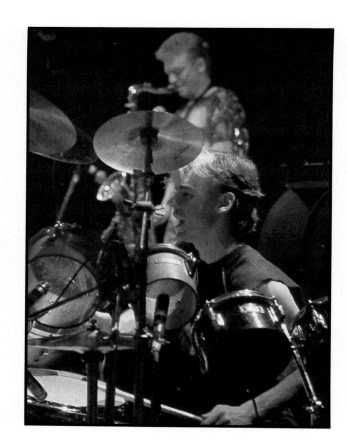

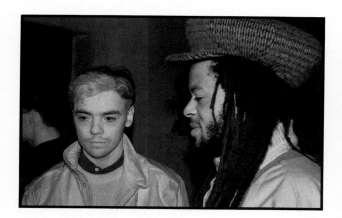

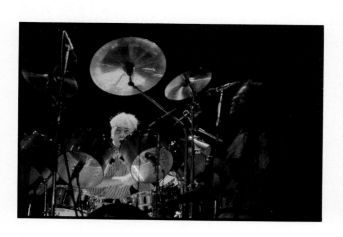

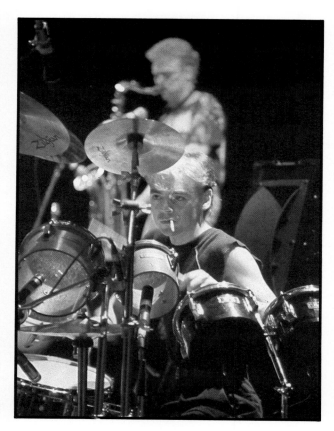

Being on the road is great. Being on the road in a band that's moderately successful is a fascinating thing to do. It is a great life and there are aspects of it that are really rewarding. I wouldn't like to do it for ever but I'm glad that I've been able to do it and I'd still like to be doing it for a while.

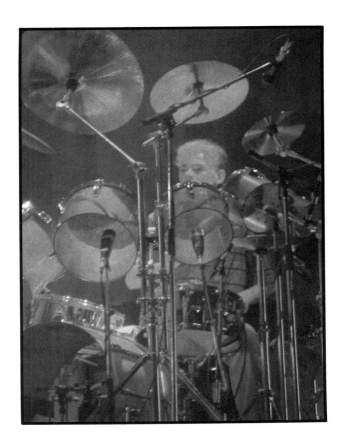

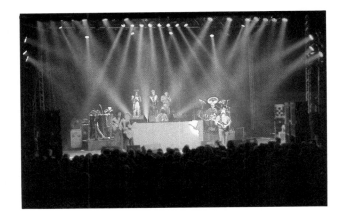

Earl

I'm into Reggae, therefore my bassline is always in a Reggae mode. When I listen to other bass players, those who can produce a tingling feeling on the back of my neck give me the greatest pleasure. Some of these players are my heroes, people like Robby Shakespeare and the Barrett Brothers. Robby Shakespeare has influenced me a great deal.

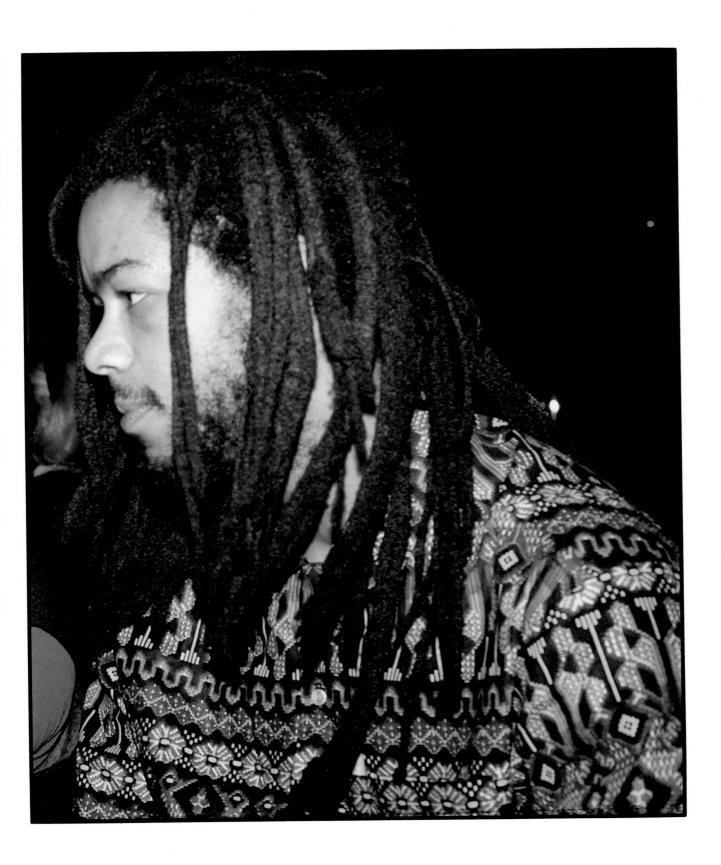

When I'm on Tour, I always want to be at home, but there again, when I'm at home I want to be on the road. It's a kind of love-hate situation.

In the early days, it was fun being on the road because it was the first time that most of us in the band had ventured outside Birmingham and the Midlands.

During this period, although we were all crushed together in the back of a Luton van, journeys to cities like London and Manchester, became adventure trips in themselves.

But times have changed from those early days, when being on the road meant we also risked our lives - at one period we had a Junky as a driver who had to drive very slowly so we would not crash, and he sometimes used to fall asleep behind the wheel.

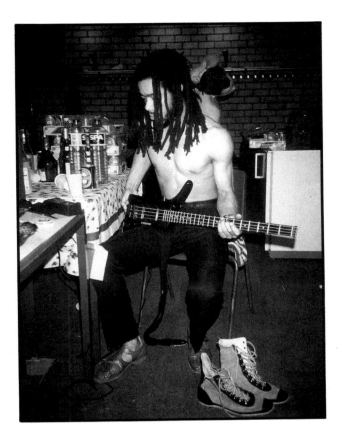

The only preparation that I ever make before going on stage is to make sure that my guitar has been tuned. I recently invested in a Steinberger bass. It's light and very easy to carry about. It's always by my side when we're on the road, and because of this I tend to practise a lot when we're touring.

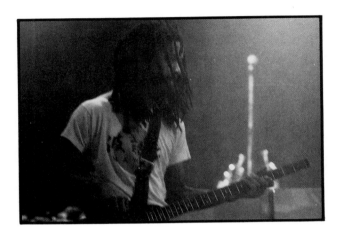

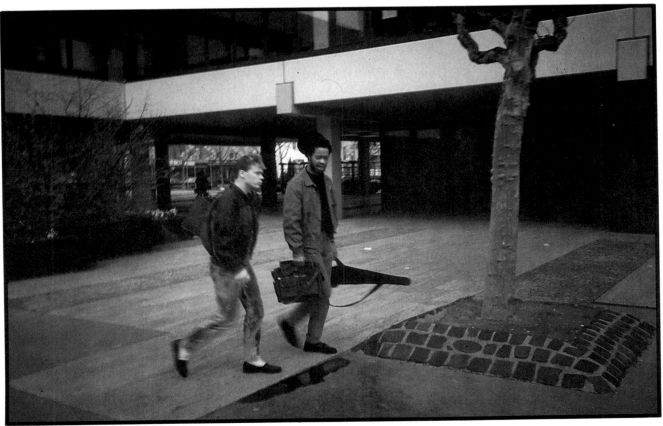

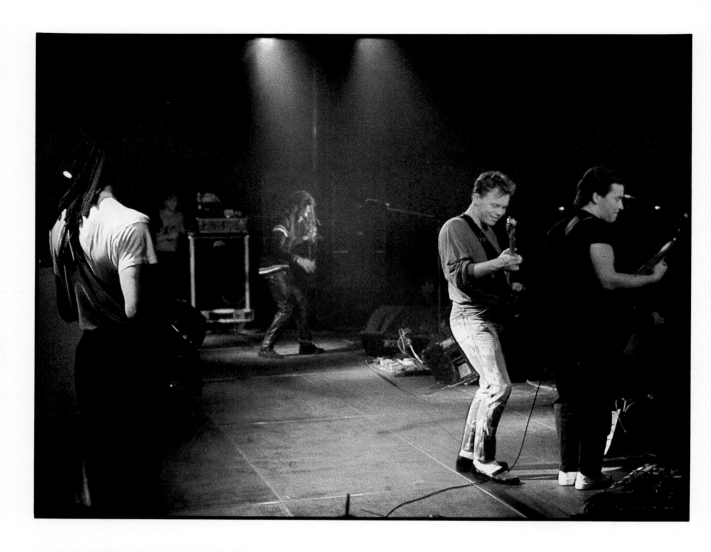

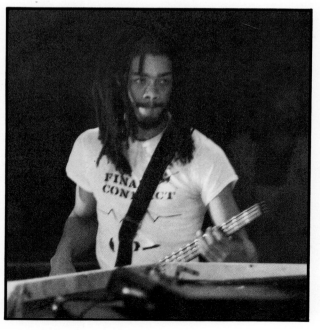

Everyone sees me as the shy one, mainly because I never move around very much on stage, not like Astro, Norman and Ali anyway. Robin used to say that "if there's a black spot on stage - an unlit area on stage I'll bet that'll be the spot where you'll always find Earl". Basically what I always do is to stand next to my cabinet monitors and as my speakers are never centre stage, it is very unlikely that you'll ever find me in the centre of the stage. I don't mind being on the side, anyhow, because I'm too busy playing my guitar.

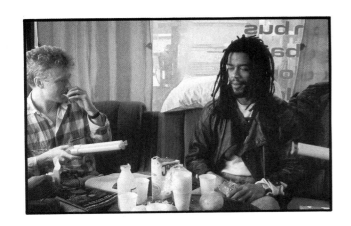

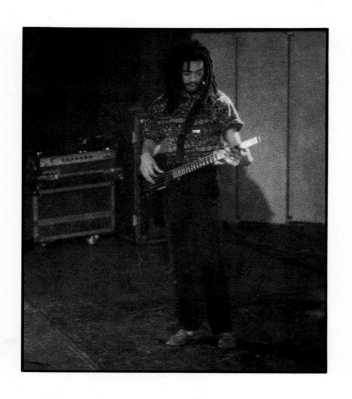

Sometimes I feel very tired before going on stage, but I soon overcome this, and after the first few numbers, always get into it and start to really enjoy it.

I find it a lot easier playing shows when we're away from home. Playing to a home crowd, especially in Birmingham makes me get a little on edge. The presence of your family and relatives and being in front of people you know really well, always makes me worry unnecessarily. This is the time that I never want to make any mistakes in my playing.

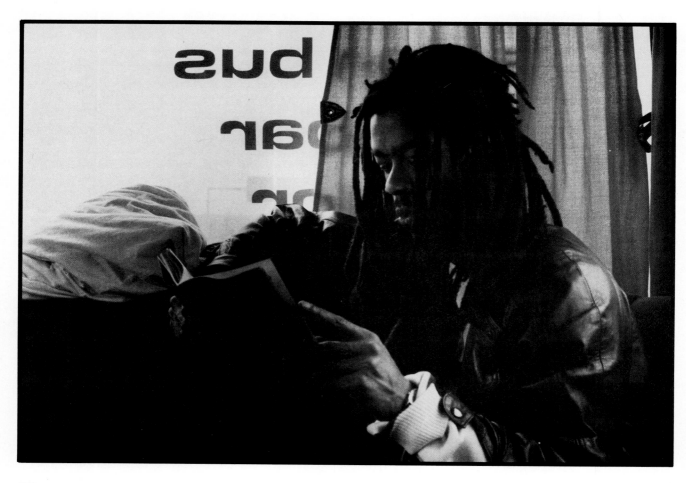

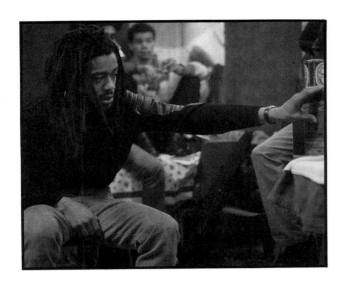

I carry this enormous ghetto-blaster with me whenever we are on the road. I've carried it round the world nearly, and it's worth it. With it, I am able to listen to the music that I and most of the band like, and it keeps me sane.

I would like to see us develop our stage show by expanding the number of musicians. I'd like to see some girls doing backing vocals, and a bigger brass section.

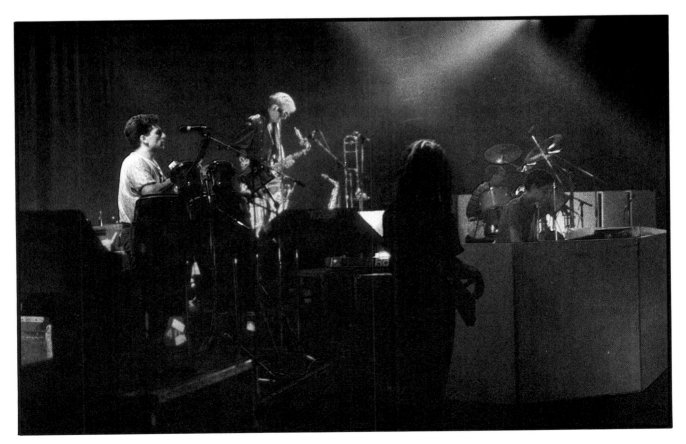

Robin

I haven't got any Idols. I've got respect for all performers. It's a demanding thing to get up on a stage and people who have not done it don't realise. Over the years, I have seen many performers, and the only show that I've ever been to that absolutely knocked me out was Bob Marley. He was the only person I've seen on stage who had it all. He mesmerised me. It was the nearest thing to a spiritual experience that I've ever had.

The only really important measure that I will always take when we're on tour is that of sleep. Other members of the band may disagree, but I always make sure I get enough sleep and I think that is why I don't suffer physically from touring, not as much as other members of the Band anyway. There is always a lot of socialising, parties, pubs and clubs during the course of a tour, and although I enjoy all these as much as anyone else, I always have to make a conscious effort to leave parties a little bit earlier. I always try and make sure that I have an average of six hours sleep every night. If I know we are getting up at ten in the morning to travel somewhere, then I'll be asleep by four in the morning. This is not always as easy as it may sound. After a late show, it takes hours to wind down. Your adrenalin is pumping away and the last thing you want to do is to go to bed. So the natural thing for everybody to do is to go out. Well I do go out but I just don't stay as long as everybody else.

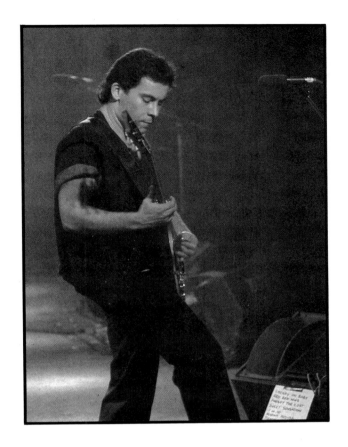

I am credited as being a lead guitarist, but in actual fact, I don't perform the same task as a lead guitarist in a rock band. I regard myself as a melody guitarist and on the whole, the kind of guitar I play compliments the bass line. I'm more or less sharing rhythm with Ali. The only sort of lead instruments as far as our music goes are Brian on Sax and Earl on Bass. The Bass is the most important instrument in the Band. The bass line and lead vocal form the melody. The makeup of our style of music is totally different from rock music and I certainly don't miss the role of being a lead guitarist. Lead guitarists in rock bands always seem to be in the forefront. I'm glad that I'm not in the same mode because if I had to do a guitar solo under a spotlight, I'd shit myself.

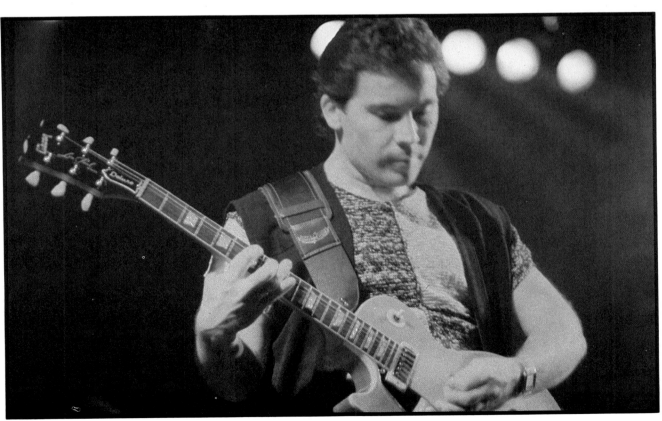

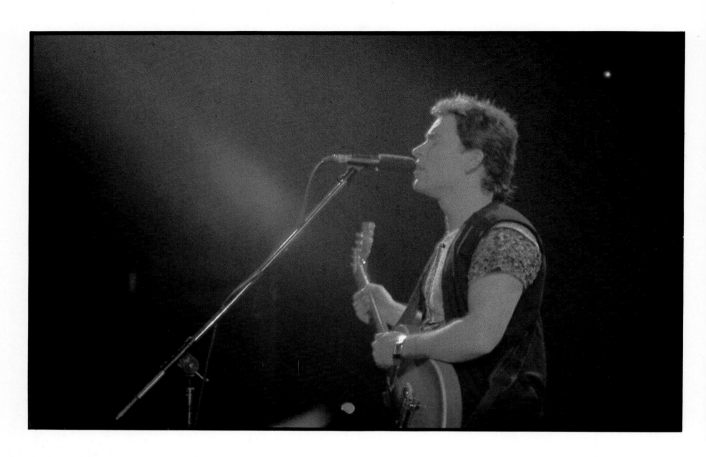

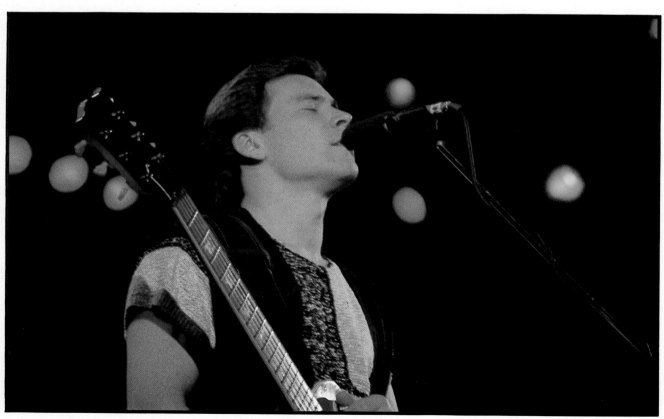

Everyone in the Band is usually nervous before every show. The weird thing is, everybody is nervous in a different way. Jimmy for instance is very nervous before we go on stage, but he's also very nervous while we're on stage. I don't feel nervous when I'm on stage, but I'm hyper nervous immediately before we go on. I usually have to go to the loo about ten times in a space of ten minutes, but as soon as we're on, I am totally relaxed. It doesn't get too bad, because there are eight of us and we've all got each other to lean on. If I was a solo performer I think it would be worse. In fact I don't think I'd ever be a solo performer.

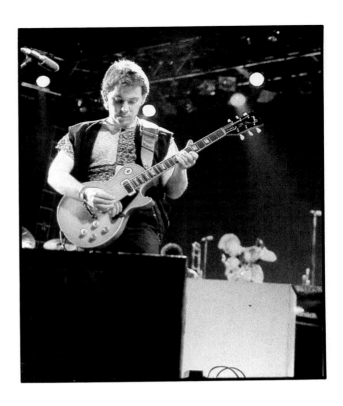

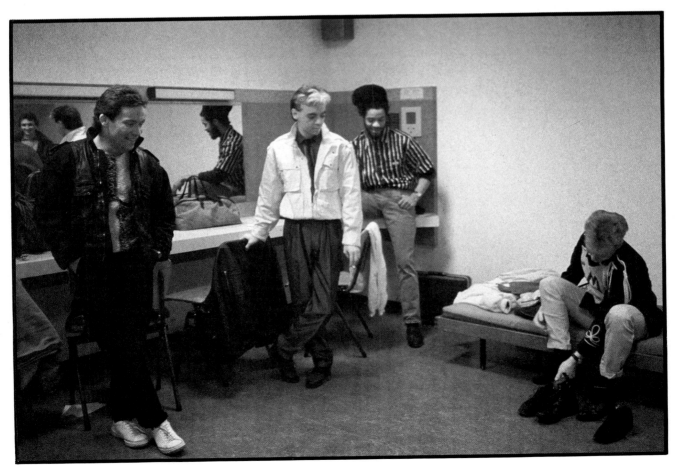

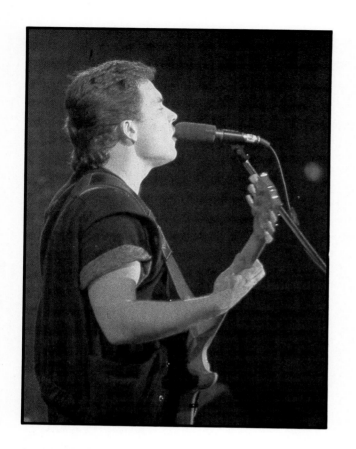

While on stage, I don't think I'd ever like to be anything but to be totally in control. I never have the urge to break loose. Although I have been known to party a little on stage, but that's very seldom. I hardly dance on stage, but it doesn't mean that I'm not enjoying myself. I have never been a frantic dancer, other members of the band are much more exciting visually. I'm quite happy for them to be the focal point as far as dancing and movement is concerned. I have fun watching them and the audience dance and enjoy themselves, and I think if I tried to join in with them, I would not be able to play or sing. That's why I tend to stand still so that I can perform the most important function which is to play the music so that the audience can dance.

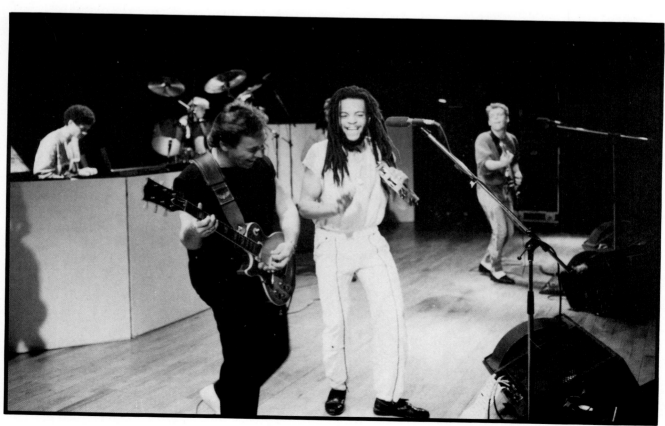

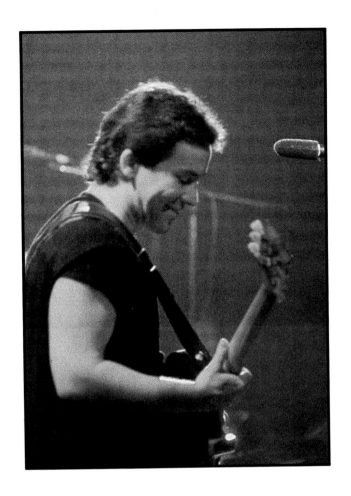

I enjoy singing on stage. In UB40, we have what is called the Brothers' Blend. I don't try to sing like Ali, but there are certain qualities in our voices that are similar. My job as a vocalist is to complement Ali's vocal. I don't see myself as a lead vocalist. Ali is a far superior singer to me. My voice is there to back Ali's and make him sound as good as possible. Normally I'll sing the harmonies and my voice is usually behind his. The nightmare of forgetting lines has been experienced by the both of us. On the whole it happens to Ali a lot more than it happens to me. I have hysterics when I realise that Ali's mumbling gibberish down the microphone. He'll be singing the tune but he'll be just totally lost. Very often in a live situation, most people do not realise anyway because Ali's diction is so bloody awful, they don't notice when he starts gibbering at them. But it doesn't happen to him that often.

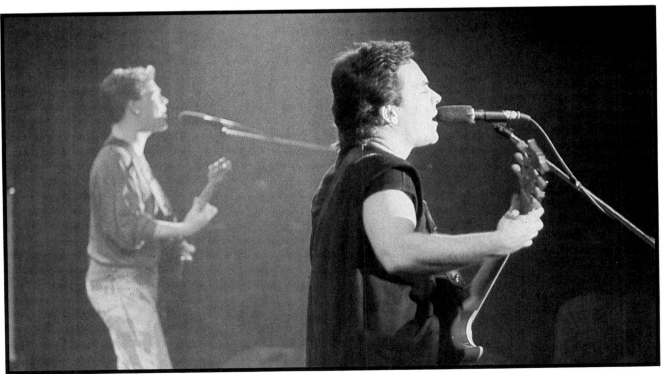

Ali

My biggest influence has always been Reggae. I can also remember being very much into Tamla Motown and Soul, especially Stevie Wonder, Al Green and the Jackson Five. I fancied myself as the Balsall Heath answer to Michael Jackson.

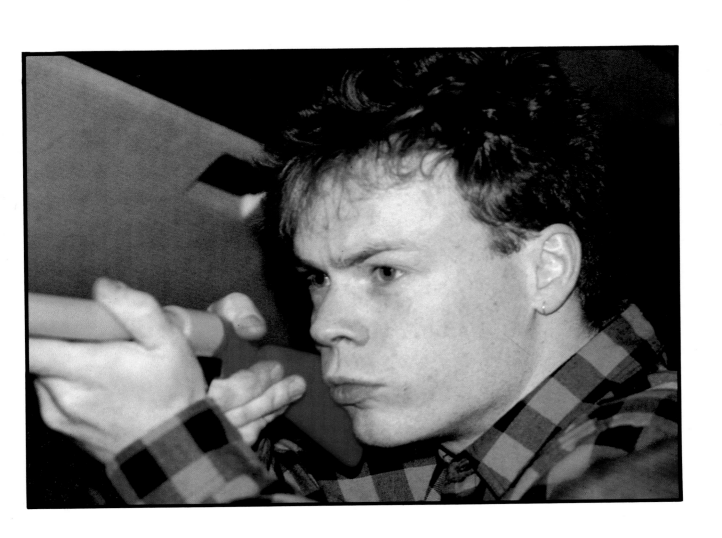

When people listen to me sing, they automatically think I sound black, that's because they always associate Reggae music with black people and the style that I sing in is taken from black music. Very often, people will ask me how come I can sing in patois. This I always find very embarassing mainly because never in my life have I ever tried to sing in patois. The only thing that I can recall having attempted was that I feel that I have tried to steal the singing style of the black singers that I used to listen to when I was young - great Artists such as Stevie Wonder and Al Green.

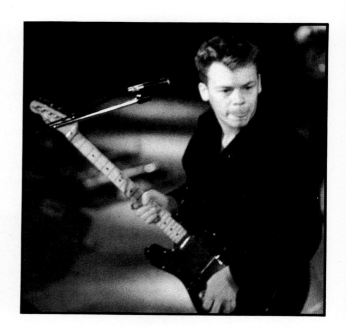

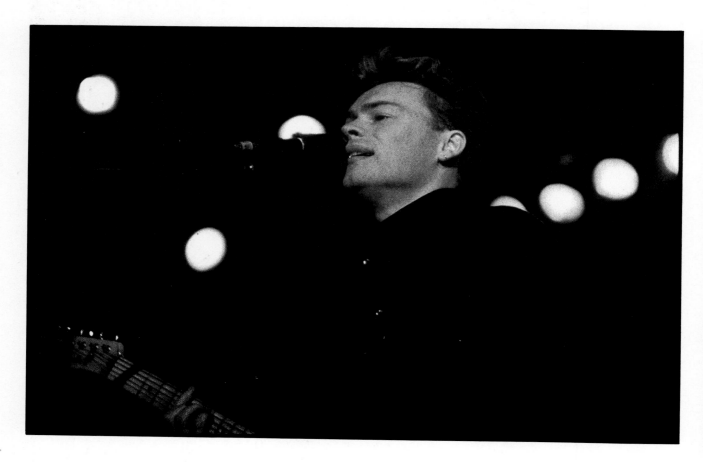

In Europe, we are regarded as a Reggae Band, and not as a Pop Band. So most of the European Reggae followers turn up at our shows when we play in Europe. But some people still regard us as a Cult Band. In this case, Cult merely means you haven't sold millions and millions of Albums.

For example, in the USA, if you haven't broken into the mainstream record buying public, you are regarded as a cult band. America is so big that achieving this big break, which is the ultimate for all bands, still takes a lot of time and a lot of drive. We are just beginning to achieve this slowly. Everytime we go back there, we play to larger audiences than we did on the previous visit. In the USA we are gradually shelving the image of being a cult band and getting recognition as a serious Pop Band to be reckoned with.

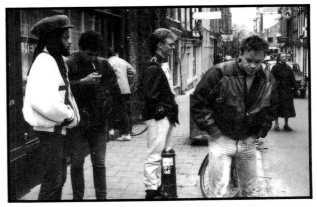

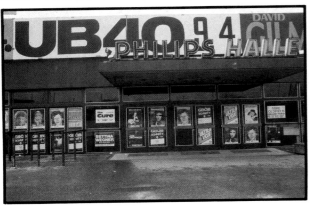

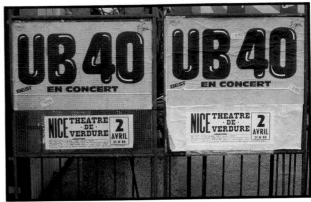

Touring is becoming a bit like a dinosaur thing. The bigger Bands and the megastars rarely tour nowadays. When we first started some years back, I thought that it was a lot of fun being away from home. But now after experiencing a number of years being constantly on the Road, I am getting to find it very tiring, and I sometimes can suffer from it - a lot of stress.

You can always tell when I am suffering a lot of stress. The palms of my hands get covered in little blisters. As a result of this, I tend to drink and smoke more when we are on the Road touring.

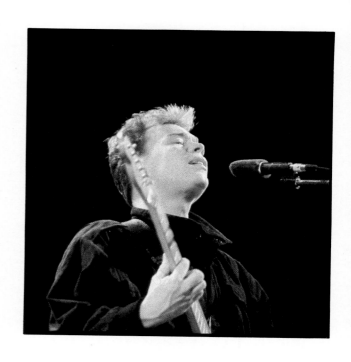

When the band first started doing live shows, I was doing most of the singing - that was hard. Although I did most of the singing, I could never have thought of myself as the Lead Singer of UB40. There are eight members in UB40 and each one of us has an equal role to play.

I put a bottle of honey on the side by the speakers where I can easily get to it - that's the only preparation that I make before going on stage.

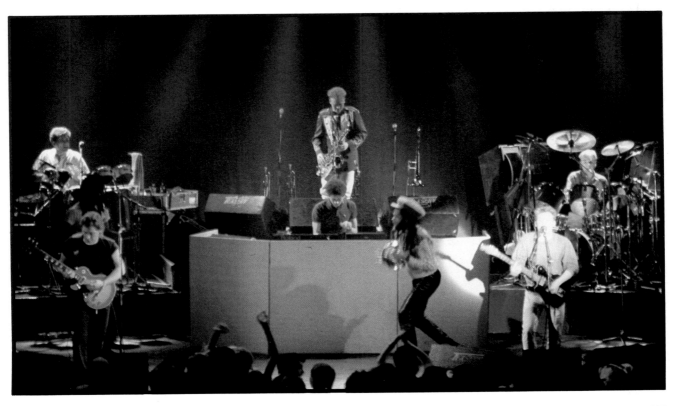

After a show, people sometimes come up to me and say "You sounded as if you were in pain" - that's because I was in pain. It hurts a lot of the time. Smoking too much doesn't help either. I think I smoke too much anyway. Maybe I should cut down on my smoking during the Tour. You never know, it may loosen the strain. Knowing me, I'll probably smoke more now.

I would let you know that a Tour has never been cancelled because I lost my voice. But come to think of it, sometime ago, two dates got cancelled, not because I lost my voice but because I got pleurisy. I could only squeak.

I am sure that, should I ever lose my voice during a tour, some one else will take over - maybe Jimmy or Mickey.

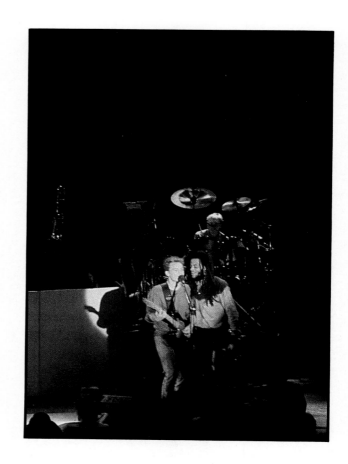

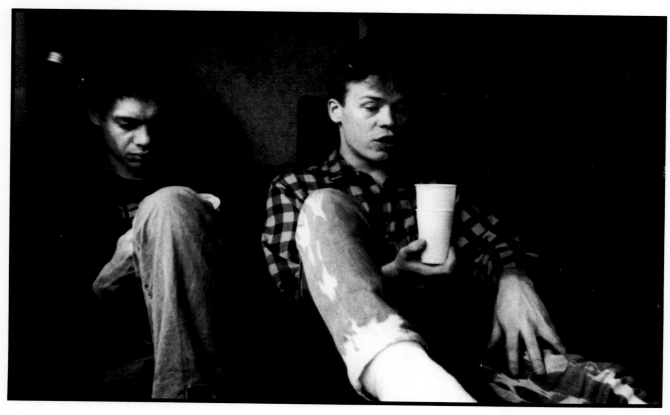

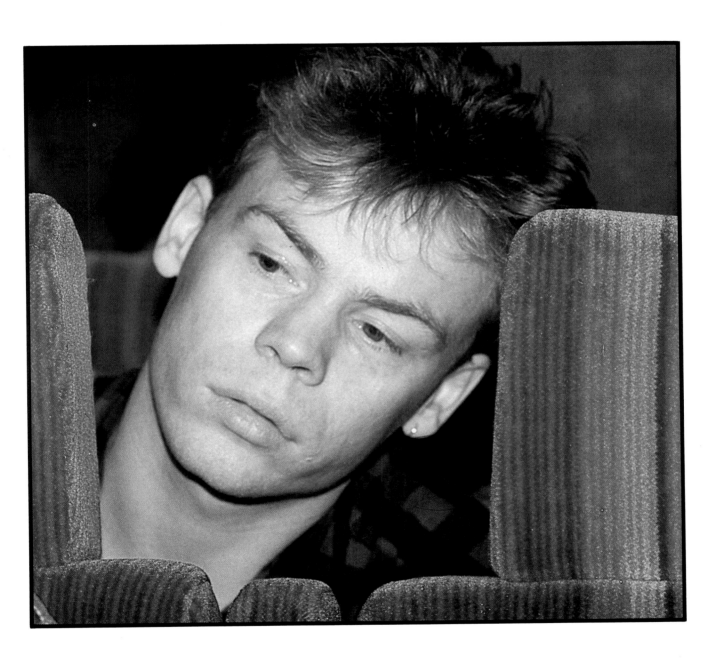

Mickey

I don't think I have got any personal ambition to be the greatest keyboard player in the world. I don't think that's really me. The most important thing is for me to enjoy what I am playing and I am glad that I can contribute towards entertaining people. I get a kick out of entertaining a lot of people and just the fact that they are enjoying something you are doing is a very good feeling.

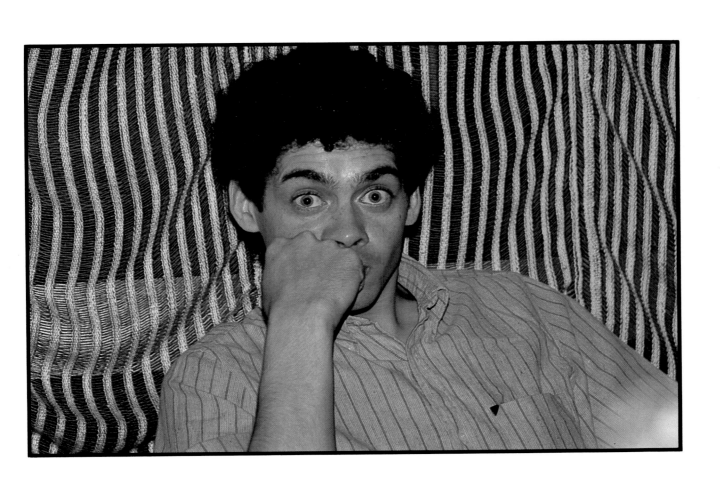

Whilst on Tour, I tend to be in a time bottle of my own. It's such a large group and because we spend a lot of time together, you can really become impervious to anything that's going on. You lose track of the news and stuff like that when you are on the road. Those things don't really matter any more. I don't notice them because my mind is always on the next show. The next show is more important than the 9 o'clock news or reading the paper.

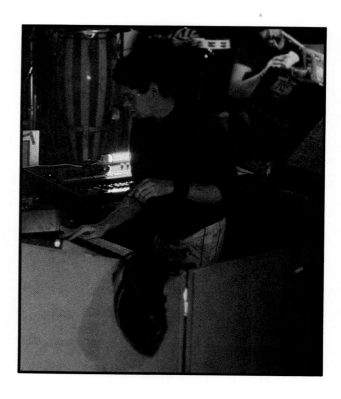

We have a reputation for being a good live Band. So I suppose that in itself is good. Doing tours is a necessary part of UB40. That was how the group started in the first place and we have progressed to playing fewer shows but larger audiences. This has made touring a lot easier and for a very lazy person like me that can't be a bad thing.

Apart from having a wash and changing my clothes, I make very little preparation prior to a show. Once on stage, I try to enjoy it all - until something goes wrong. If my keyboards go wrong I won't be that pleased but I'll weigh that against being on stage playing and I always end up feeling lucky and happy.

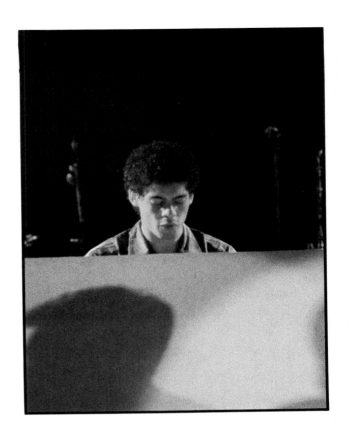

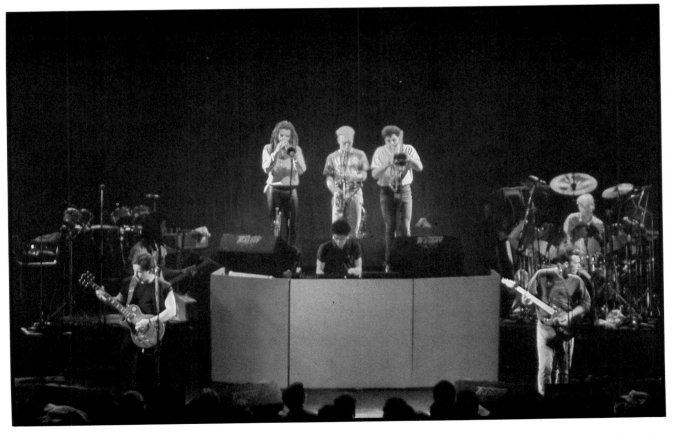

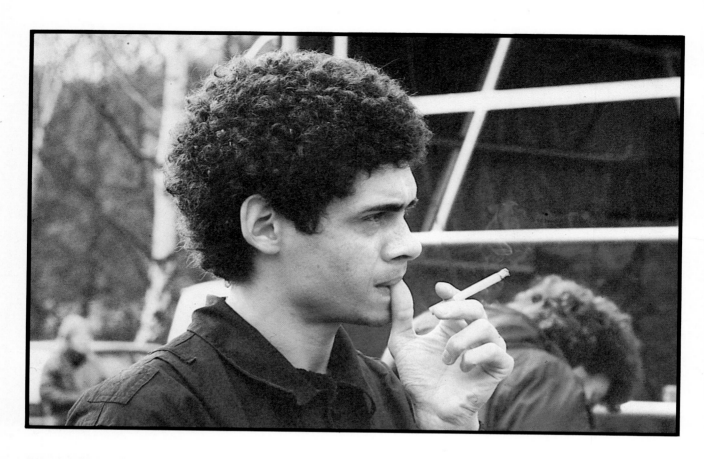

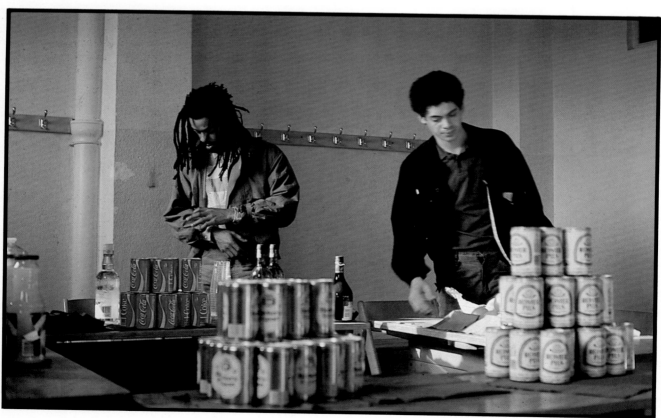

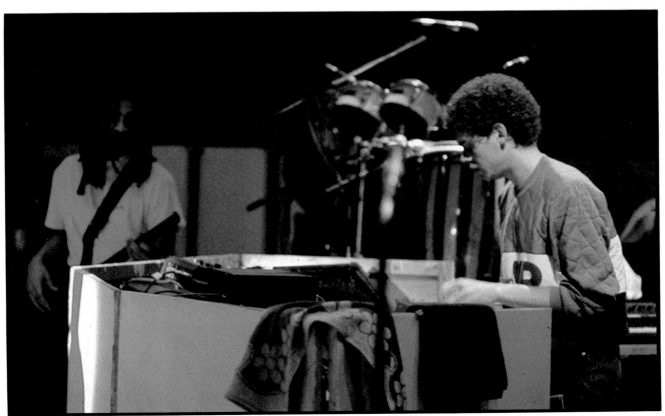

The early shows used to frighten me because it was a whole new experience. Getting on stage was so totally out of character from anything I could imagine. Nowadays some of the venues are so large that you can't really comprehend the size of the audience that you are playing to. You sometimes feel as if you are on a pedestal with thousands of eyes on you. Knowing this makes me very shy and I tend to keep my head down most of the time and always try to avoid any eyeball contact.

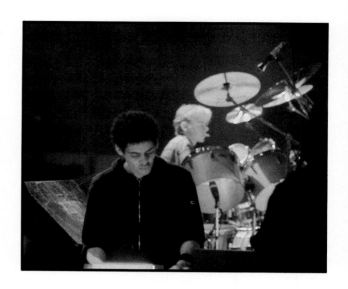

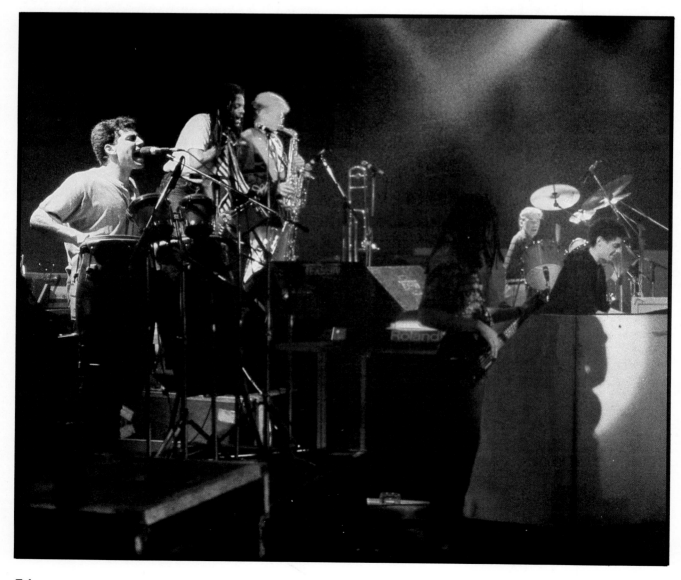

54

My main concern is to play a good show and hopefully to entertain in doing so. I'd like to feel that the audience are getting their money's-worth.

Well if you don't get bottles thrown at you, then you can't be going far wrong. When they start throwing the bottles in my direction I'll take the hint.

I keep a really open mind to music. I used to just listen to reggae music all the time, but now I am broadening my taste. My only musical ambition is to be remembered for having slightly helped in the popularisation of reggae music. It would be nice to be remembered as just another reggae musician.

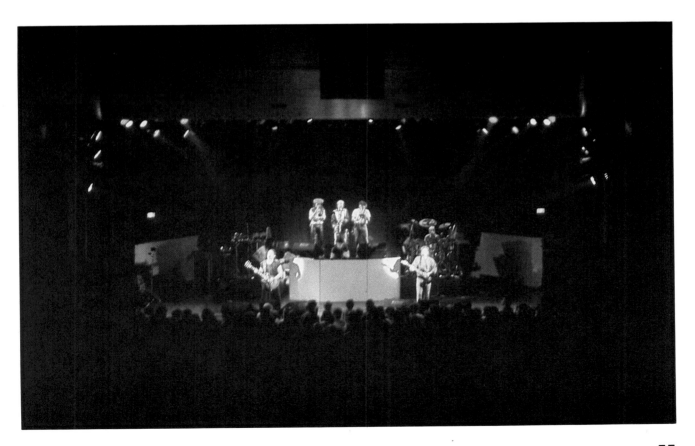

Brian

My style of play has not been modelled on anyone. There are great musicians, who I consider to be my heroes, people like John Coltrane, Eddie Garfield and Stan Getz. These and other Jazz musicians are respected just for turning up for a show. It will be my dream come true if I ever find myself in a similar situation. But it could be another fifty years before I will be able to play anywhere near their standard.

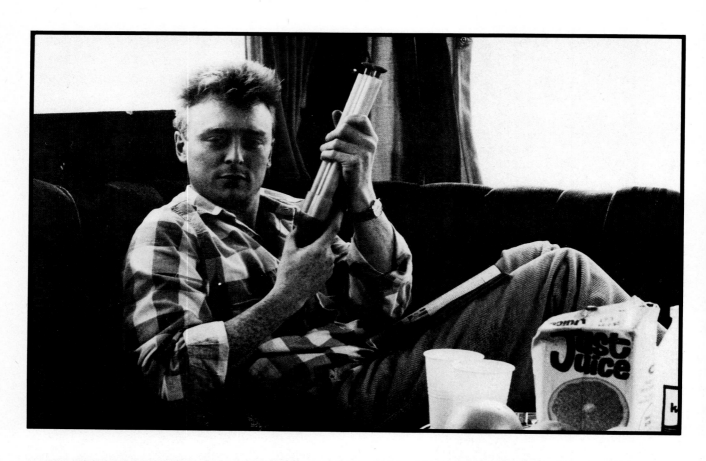

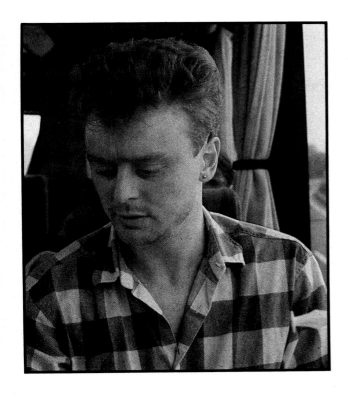

I enjoy touring, but I also miss being away from home, I think most of us feel the same way because of our strong family ties in Birmingham. In the early days, I used to think how wonderful it was that we were able to make friends all over the world, but I don't feel that anymore. It's all a bit too preconceived. You meet them because you are in a band and a lot of people tend to use you in a sense, for some kind of credibility. They tend to think you're important because you've had a hit single or album. It has all become too false. I tend to shy away from it now and I don't feel secure making friends outside the Band. Not any more. This means that I spend a lot of time on my own and because of this I tend to act silly and get drunk so that I don't have too much time being intellectual with myself. There is not enough time to study things that might be on my mind.

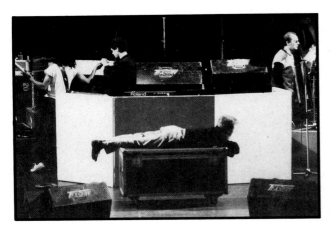

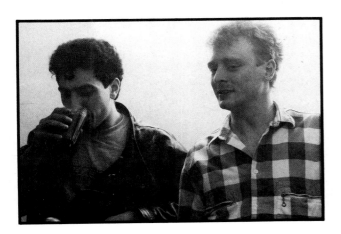

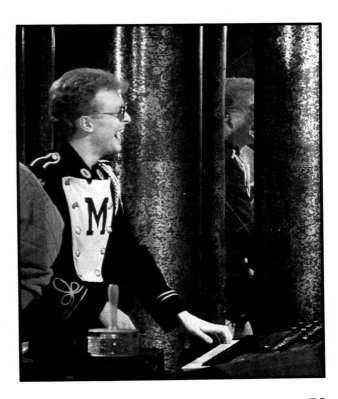

The saxophone, being an accoustic instrument, I can carry it around with me and when I get into a hotel room, I'll generally practise a little and at the same time suss out things the night before a show that I may not be certain of. Reeds and pads may not be working well. I'll get my screwdriver out and tighten them up a bit.

Before every show, you will always find me constantly tuning up my saxophone. To avoid the accoustics in the tuning room, I'll point the bell of the horn against a wall. The sound bounces back off the wall giving you a clearer sound. By doing this, you can hear how good your reed is or how well your lips are holding up to it. You get a truer impression of the notes that you are playing than you do just playing into the open air. Actually the best place is to point the bell of the horn close to a corner in a room. The notes bounce straight off each corner and straight into your ears. You hear yourself just a little bit better. You sometimes look as if you're having a pee against the wall but that's the best way I know to get the best sound.

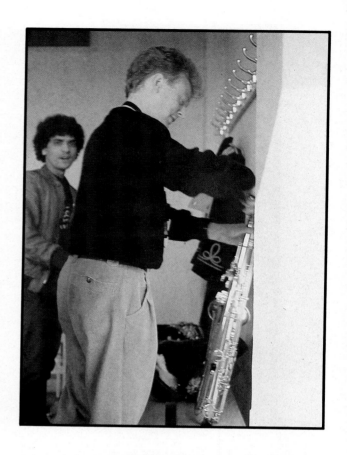

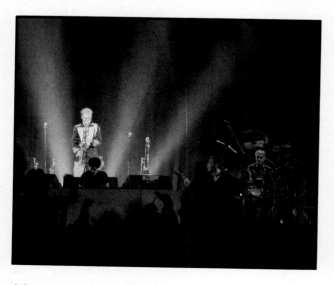

60

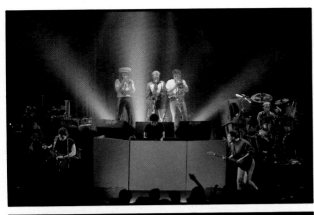

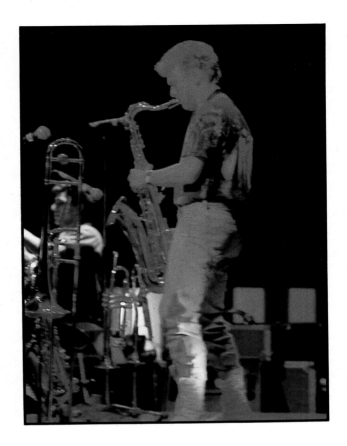

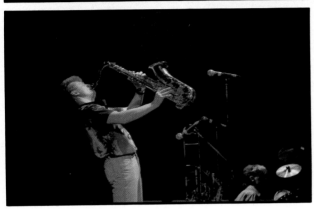

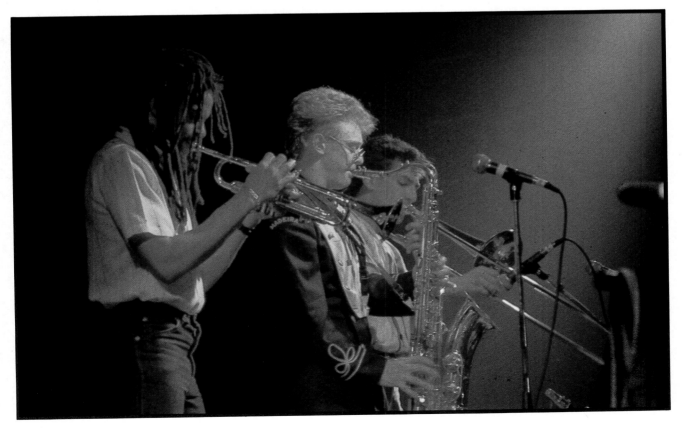

I am always far too nervous before a show. I get nervous right up until we go on stage. Not nervous for myself or what I'm going to do, but nervous of the audience. I am always very conscious that they are discerning people out there.

I like the confrontation of you pitting yourself against somebody else, and saying to them, 'I really hope you like what I'm doing because I'm doing the best that I can and I want you to clap.' It's a great feeling when you see people reacting to what you are doing - especially when the reaction is a favourable one.

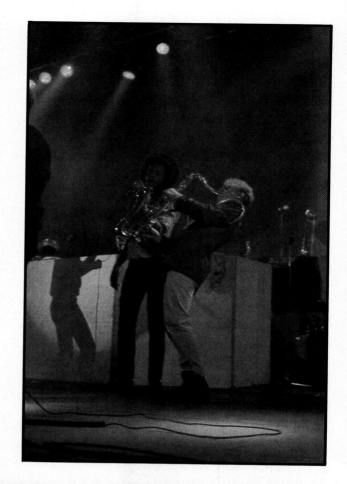

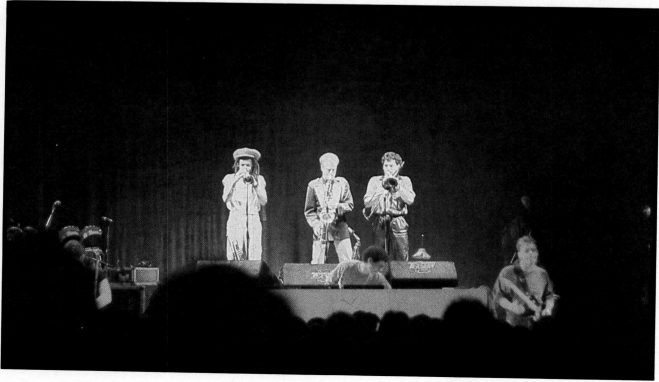

I think of myself as part of a horn section rather than a saxophone player and I see my playing as an embellishment to Ali's singing.

I find touring and playing live shows one of the most important aspects of being in a band. It is very important for me to show my wares face to face with an audience and not through the TV camera or some glossy pop magazine. It's not somebody else trying to interpret your work. It is actually you and the audience. They are out there receiving every note you make and reacting to it. Whether the reaction is good or bad, it is real and I can't ask for anything more.

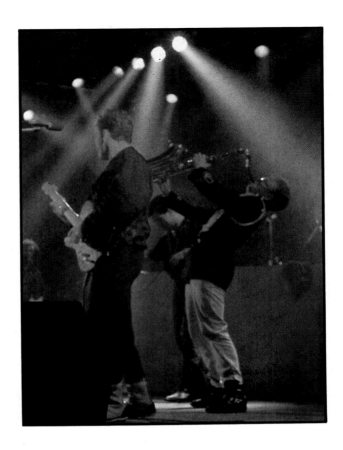

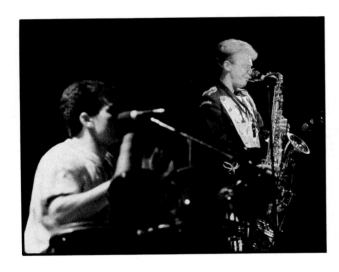

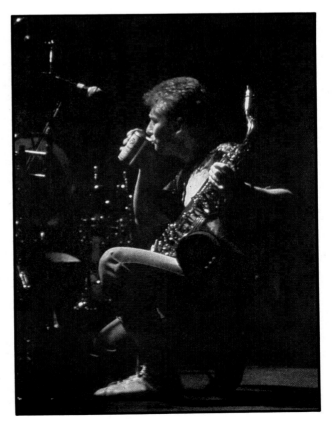

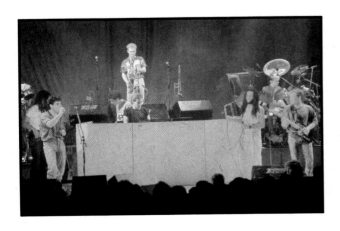

Norman

Before every tour, and the days leading up to a tour, the most important thing for me is to make sure that my house is in order and that the needs of my family will be met during my absence. Once I have my family's needs sussed out, it gives me peace of mind, and means that I can concentrate and prepare for the tour.

65

I enjoy playing in front of large audiences. The only aspect of touring which I don't like is the travelling itself, hopping from one city to the next. The amount of time taken up by travelling during a tour is too long, I find it very tiring and boring and always wish I was at home with my bambinos and my loved one.

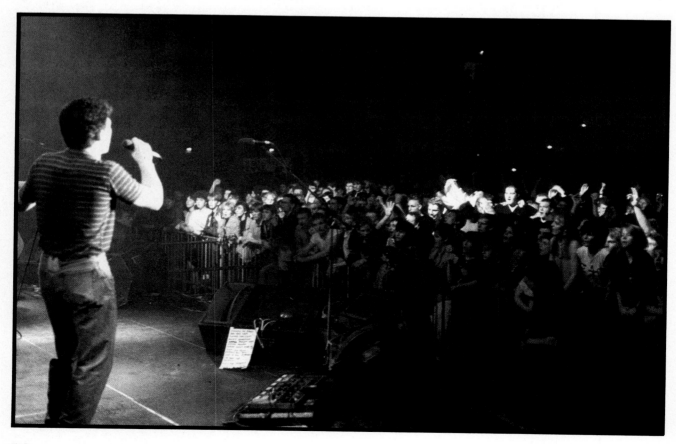

During a tour I always look forward to going on stage, and on the whole I always end up having a good time, whether I'm behind my percussion, playing trombone, or singing. But I find that I would prefer to stick to percussion because I always feel at home playing my percussion. I'm still very much learning how to master my trombone. As for my vocals, I get so nervous I often break out in a rash.

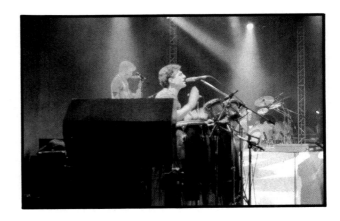

Since the release of 'Labour of Love', we've included 'Johnny Too Bad' in our shows. 'Johnny Too Bad' marked my singing debut in the band, and I know that while I'm singing this number on stage, I obviously become the centre of attention. Knowing this puts me under pressure and I can fuck up quite easily when I'm under pressure. But the funny thing is in all the other numbers, when Ali, Astro or Robin are doing the main vocal, I always sing along in the background. I don't mind doing this because I know that I can make a mistake and the audience will never know that it was me that went wrong. But even singing in the background I can remember used to make me get nervous. Maybe the time will come when I won't be nervous doing the main vocal.

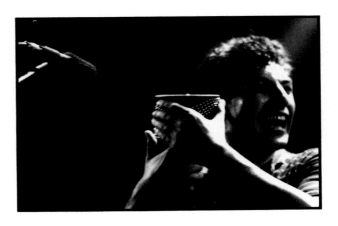

My nervous tension means that I drink an awful lot when we're on tour. I drink more on tour than at any other time anywhere.

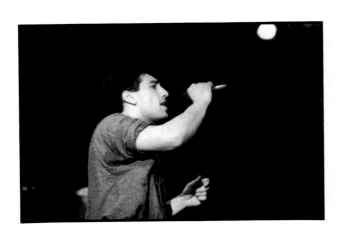

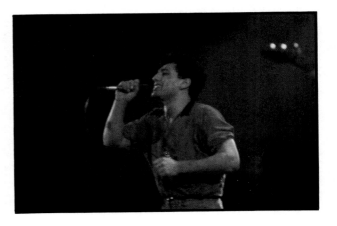

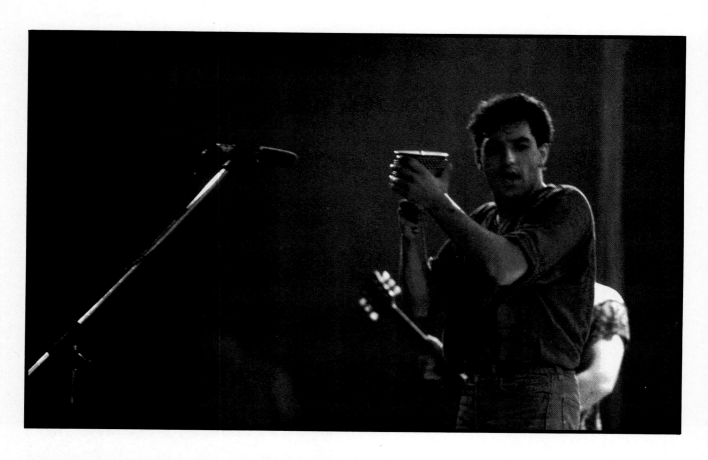

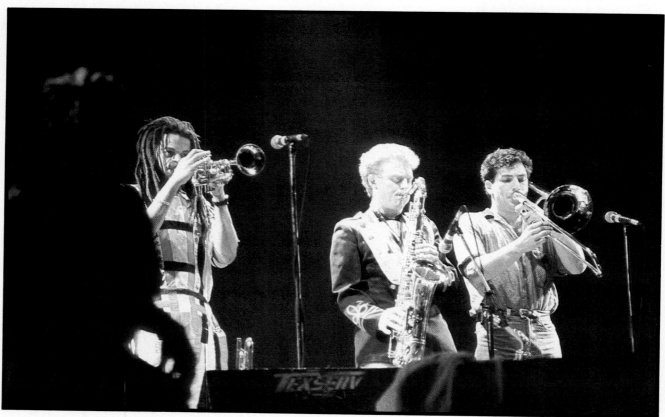

Having played the trombone for some time now, I'm at last beginning to enjoy it. When I first started to play the trombone, the instrument seemed like a big threat and I can still remember saying, 'God no I've got to go and play trombone in the next number'. This used to cause me all kinds of problems, some of the problems I'm now having with my singing. I used to practise and practise and practise. Now I feel at ease with the trombone and I can now also play it in tune.

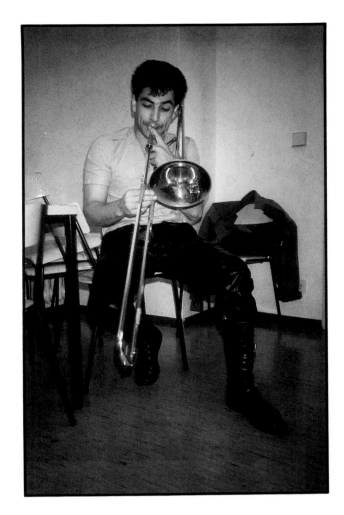

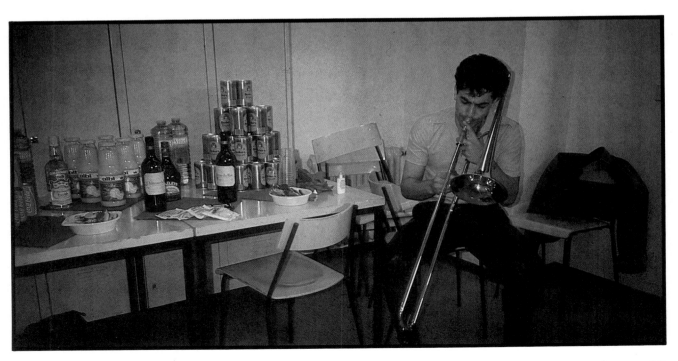

The best time on tour is the end and the homeward journey. The worst time is when you have to do the extra publicity on T.V. or radio. I always find the publicity parts quite upsetting because they are always arranged on your day off.

I think that playing my congas well is something for which I'd like to be remembered. Why? The simple reason is that I like playing them, they seem like my instrument. I'd like people to say, well he's alright on them, he may not be brilliant or amazing, but he's all right.

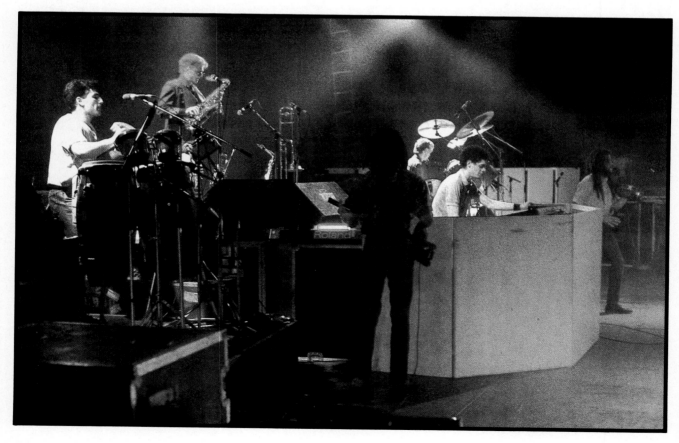

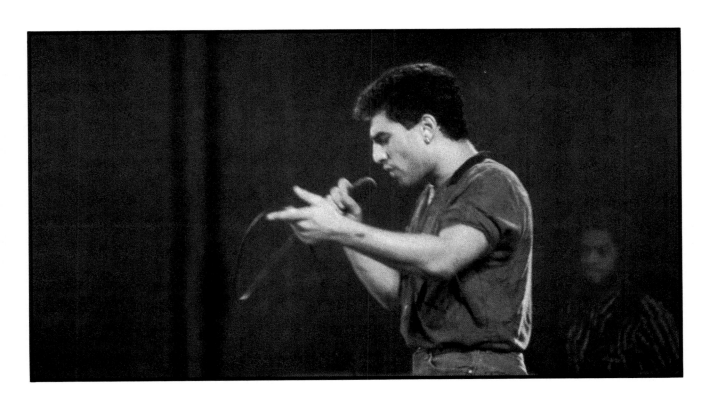

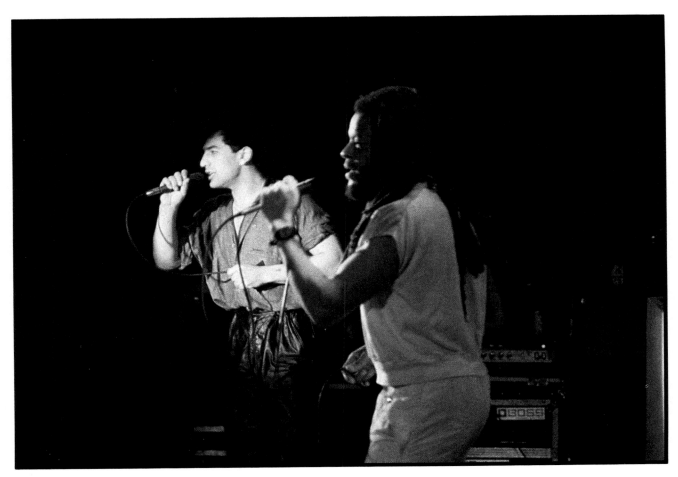

Astro

I really enjoy performing to live audiences. But I always have nightmares prior to television appearances. This may sound silly and I do know that most people, audience and crew alike, want to see us do our best, but however much confidence I may have beforehand, once the camera starts recording I become totally immersed in a nightmare of my own. I am always concerned that there are millions watching every move we make, many may be recording it and should we make any mistake, they'll play it back over and over again - in slow motion. Some people aren't kind enough to let you forget your mistakes, I can never handle embarrassing situations like that. That's why I have such terrible nightmares about TV appearances.

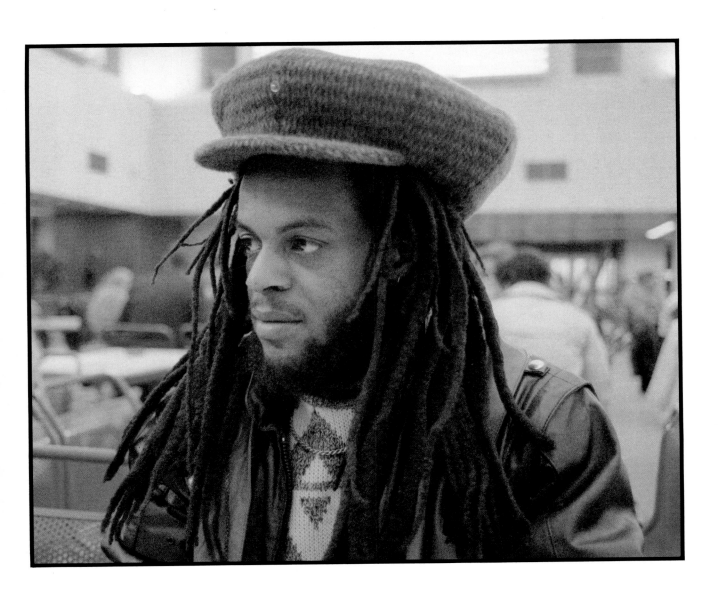

Whilst on stage, I am always addressing the audience. I'll feed off them and they'll feed off me. If I don't get any feedback from the audience, it will affect my performance and when this happens, I always want to get it over and done with. To avoid this, I always make sure I have the audience on our side right from the start of every show, even if it means having to go into the auditorium myself, coax people out of their seats and make them dance and enjoy themselves.

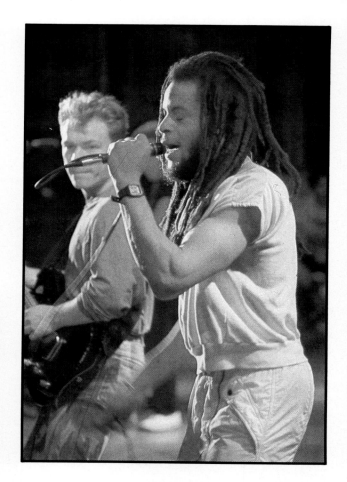

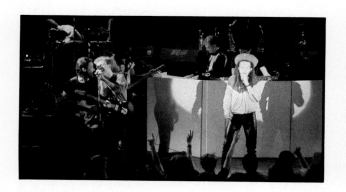

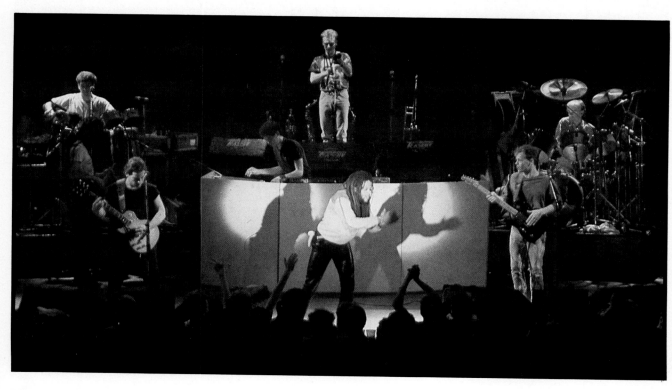

Toasting is an alternative adaptation to a backing track. If you've got a backing track, using the same music and the rhythm of the original, the toaster will put his own version of lyrics on top of the same backing track. Toasting is so versatile that his new lyrics can be relevant to what the singer is singing or perhaps it may have nothing to do with it. A toaster does not have to use the actual melody of the song. Very often, a toaster will create his own melodies. He will do this by shifting his emphasis between the different instruments. For example, if a song has its melodies built around the keyboard, I may then decide that I'll build my toasting around the bassline.

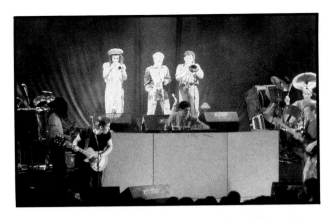

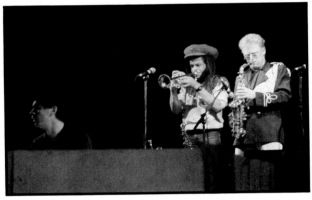

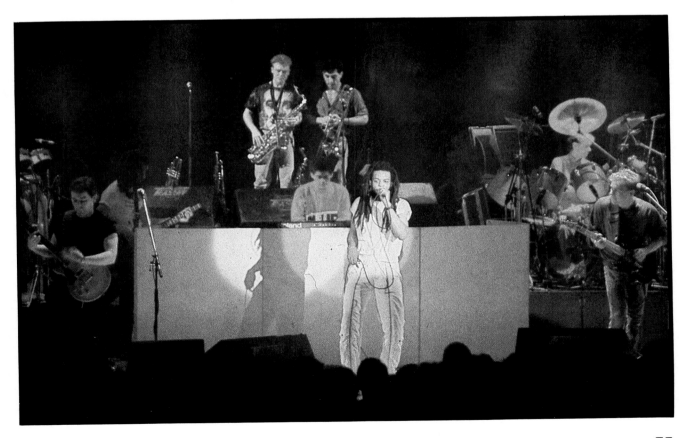

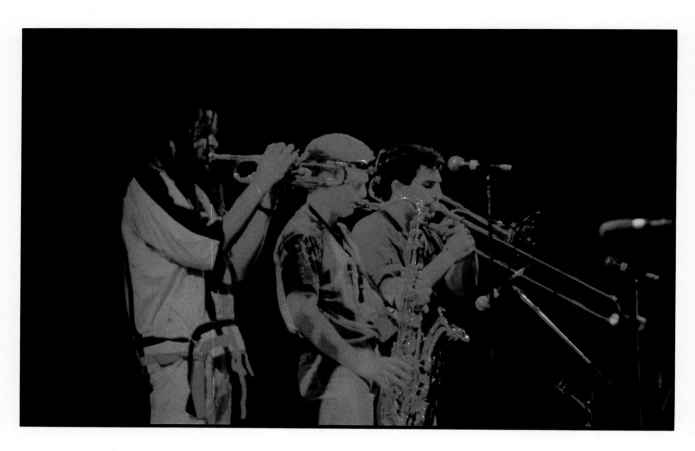

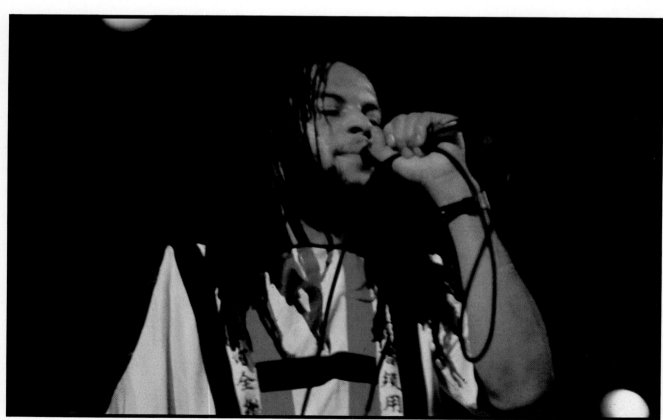

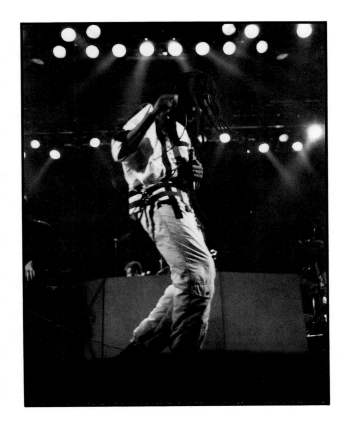

It is true that many people may find if difficult to understand the lyrics used by some toasters. This doesn't bother me because I have accepted the fact that a lot of our audience probably haven't heard any toasting apart from me. Toasting is something you either like or you hate. But it is something that you are likely to appreciate by listening to it frequently. I'm glad that the people who come to our shows are prepared to listen to quite a lot of toasting.

After seeing a UB40 show, those who have never listened to any toasting before, will I hope have had some sort of introduction to it that will encourage them to listen to more.

I'll get the audience participation by using direct eye contact making them feel their personal involvement. I find that toasting gives me a lot of freedom on stage, but with my horn, I find that I am always very restricted. You have to be within six inches of the microphone or you are not going to be heard. It restricts your movements. I also feel that I am more proficient at using my voice than at using my horn. I prefer toasting, because it gives me a direct contact with the audience. Playing the horn sometimes gives me the feeling that I am just trying to fit in with the number which is being played.

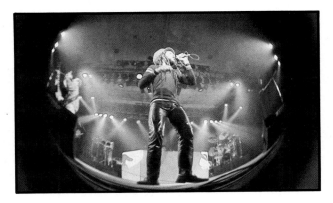

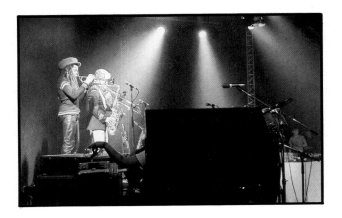

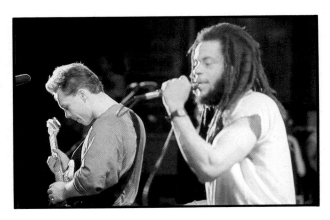

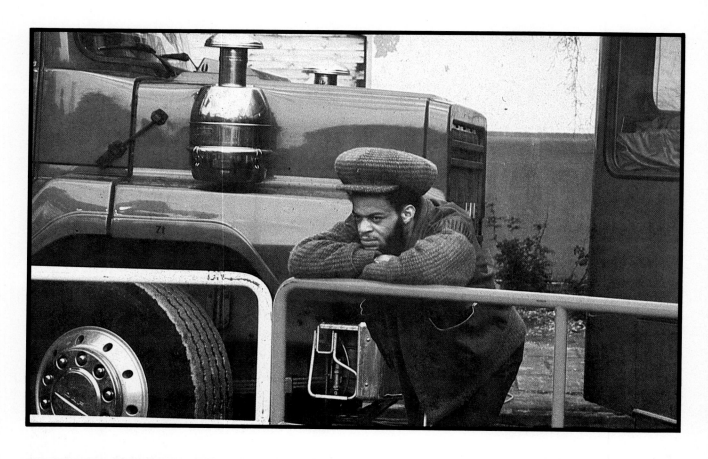

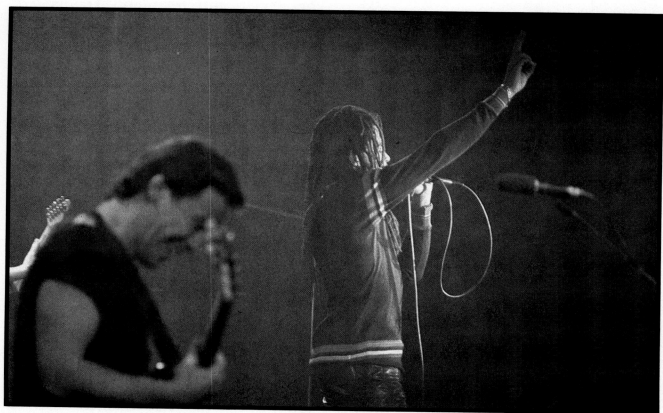

At present there are many talented toasters around and many have influenced me in some way or another. Big Youth, U-Roy, Shorty and the President are toasters who have my greatest respect. But Dennis Al Capone influenced me the most. He was responsible for me becoming a toaster.

I have always been interested in toasting and straight forward singing is something I have never considered. In UB40, if I had to sing, I am sure I'd give it a crack. What's a few more grey hairs amongst friends?

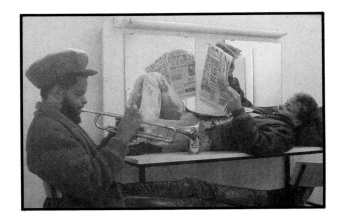

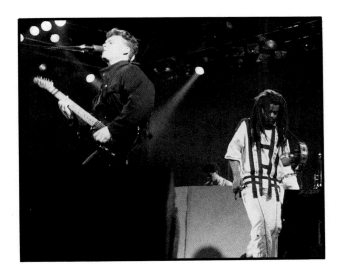

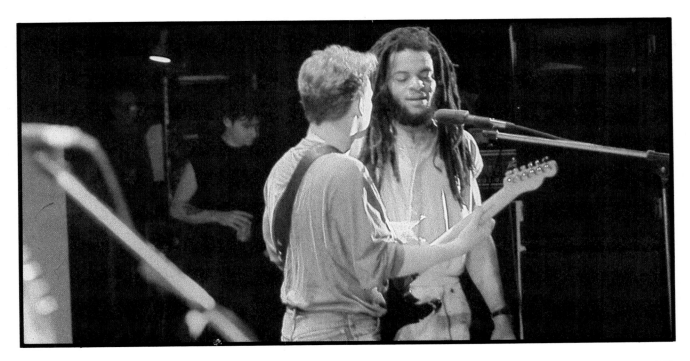

Ray

Ray 'Pablo' Falconer is elder brother to bassman Earl. On tour, Ray acts as sound engineer and is responsible for the overall sound of the Band on stage. He has mixed every show that UB40 have ever played, and is regarded as the ninth member of the Band.

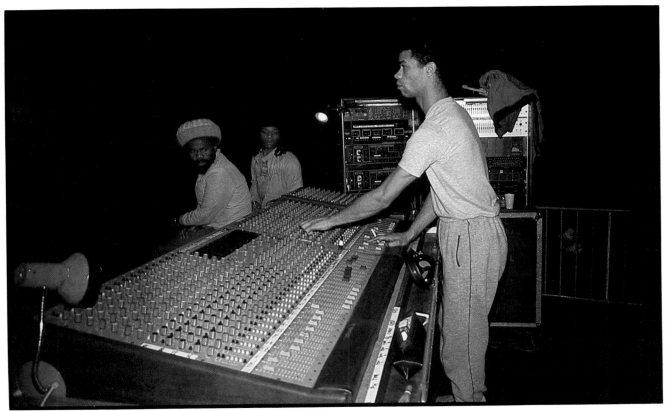

Ray at work.

Ray at play.

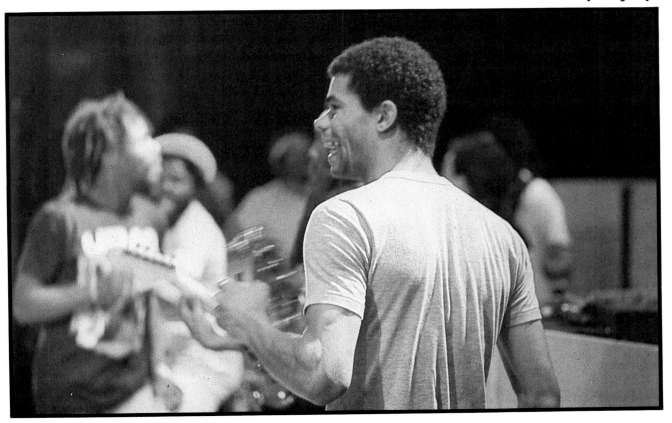

Crew

Like UB40, a majority of the crew are Birmingham based, and most have known the Band from the beginning. Anthony Bradbury(Animal) has been with the Band right from the start. He's responsible for the Band's instruments and electronic equipment, both on tour and in the studio.

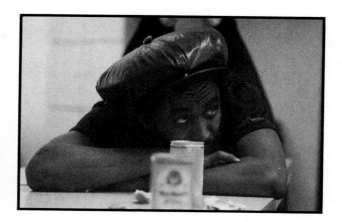

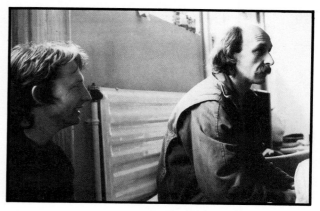

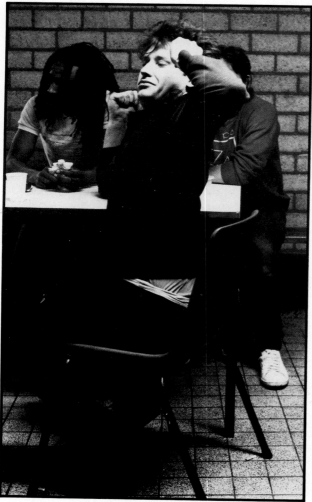

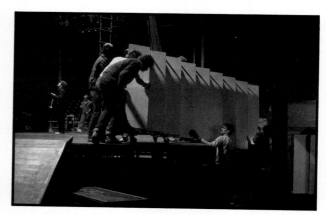

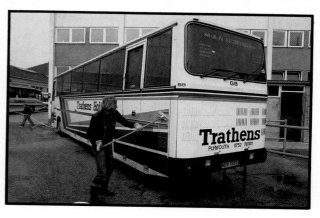

84

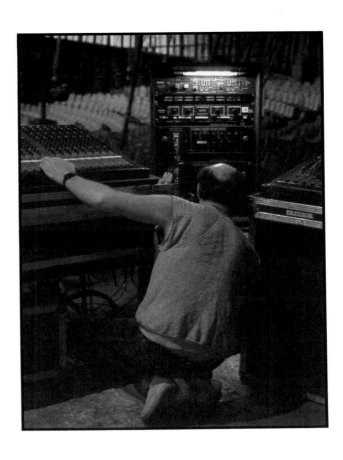

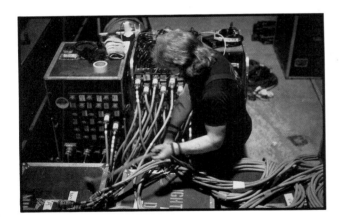

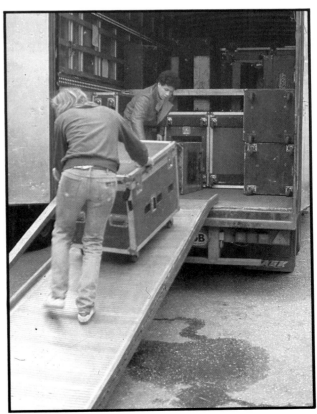

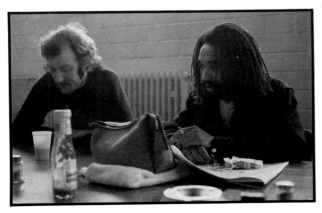

Fans

We've a very strong hard core of followers. These are those who'll buy our records and see our shows whatever the press reviews may be. We also have those who are a crossover between the hard core fanatics and the general pop followers. You have to have this part of the audience or you don't get to number one. No band has a hard core following that's big enough to give you a number one album or a number one single. So we are lucky in that we have got the best of both worlds.

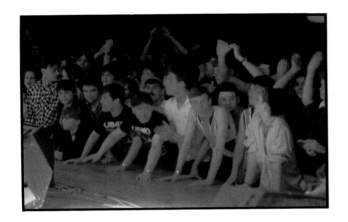

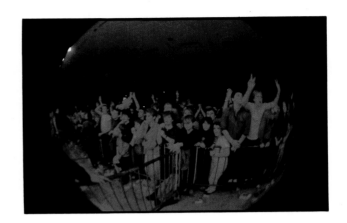

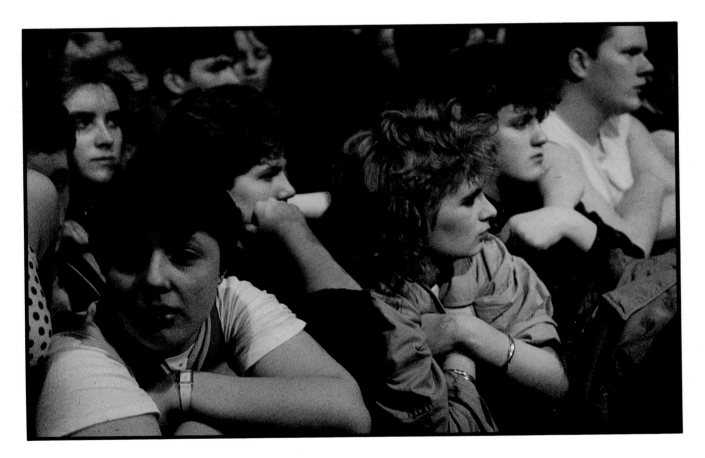

We've built a reputation over the last five years for being a good dance band and on the whole we think that's why people come to see us. We will always play dance music, because that was the reason the Band was formed in the first place. Our style of dance music tends to cross all barriers. It does not matter what country we're in. If they do not understand our English lyrics, they'll always enjoy the dancing and the happy atmosphere.

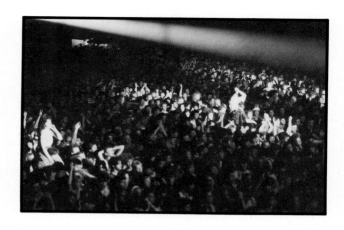

Our audiences are always very good. We don't have to coax them into singing along or taking part. If the Band stop singing, you'll find that the audience carry the numbers on. They know our music so well and it is very rare that we have to work on them to participate.

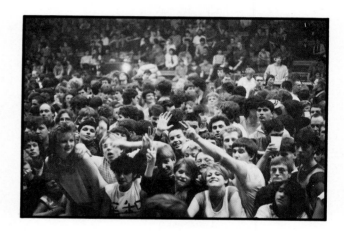

We introduced the ticket reduction for dole card carriers and since we did that five years ago, it has become a regular thing. Most bands will now give a reduction to the unemployed and we are proud to have introduced the system. On the whole we try desperately to always keep ticket prices below the asking price for other similar bands.

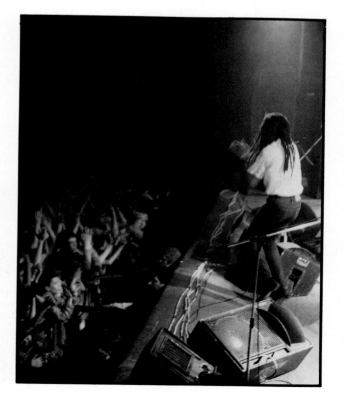

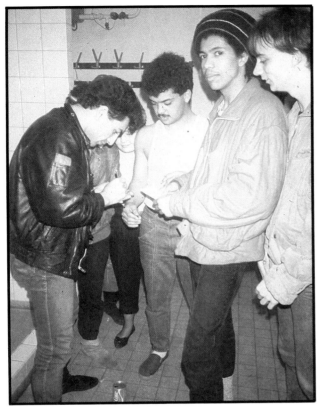

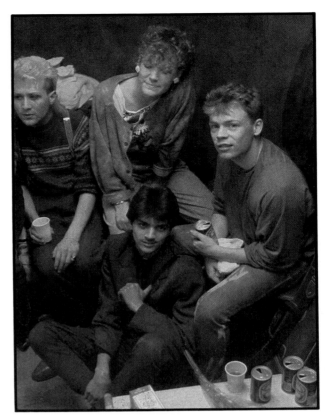

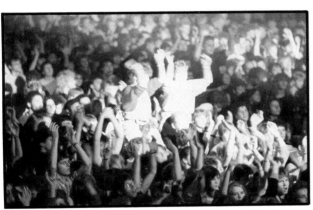

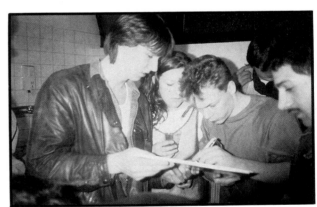

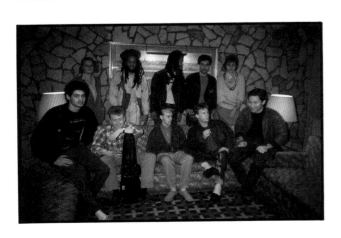

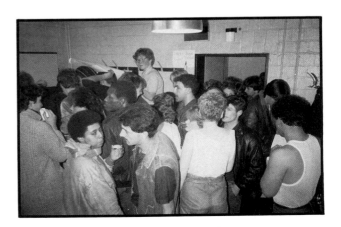

Media

We don't really care what the press say about us as long as we have got an audience. There's good and there's bad publicity but none of it seems to make much difference. It doesn't stop you selling records and it doesn't stop your audience coming to see you. On the whole, sensationalist press is pretty immaterial. It is very insignificant and people don't care much about it.

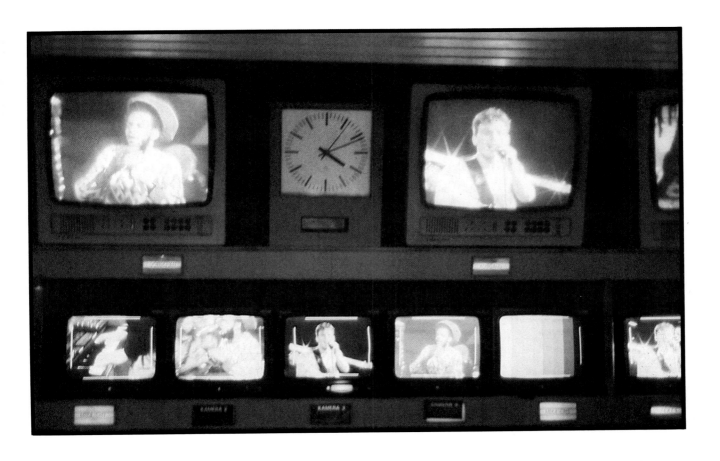

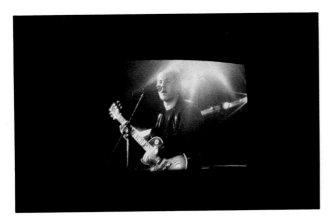

Bands' off stage behaviour is due to the nervous tension that they constantly live with. Bands do tend to misbehave because when they come off stage, they are on a high. Their adrenalin's pumping and they're ready to go. They tend to do things that they probably wouldn't do if they had not been on stage. On stage they've been in front of thousands of people. They've achieved a high. This tends to make people get a little boisterous but so what. The sad fact is that because you are in the public's eye, whatever you do is blown out of proportion. It doesn't really warrant a column in the newspapers. It is not newsworthy but the fact that you are in the public eye, means people are interested in what you do for some unknown reason.

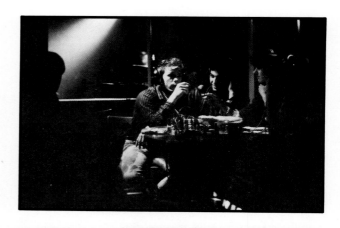

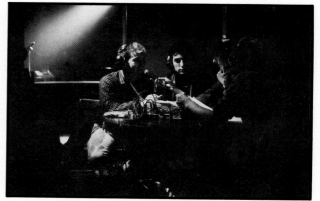

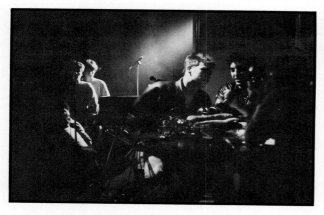

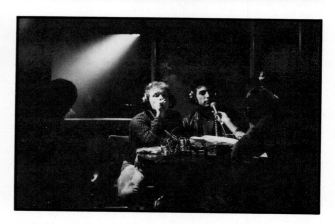

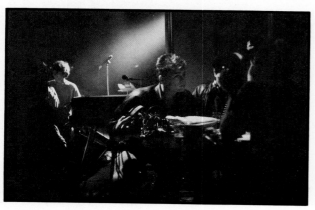

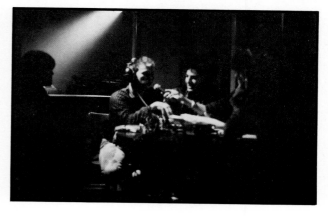

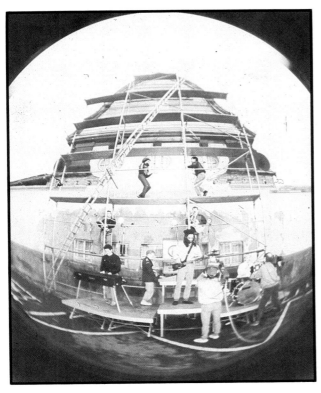

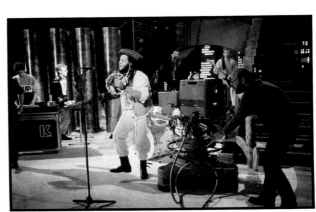

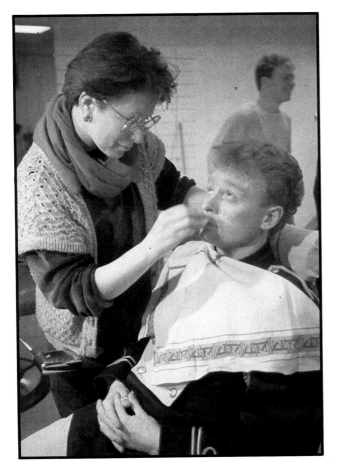

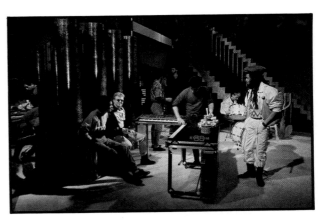

93

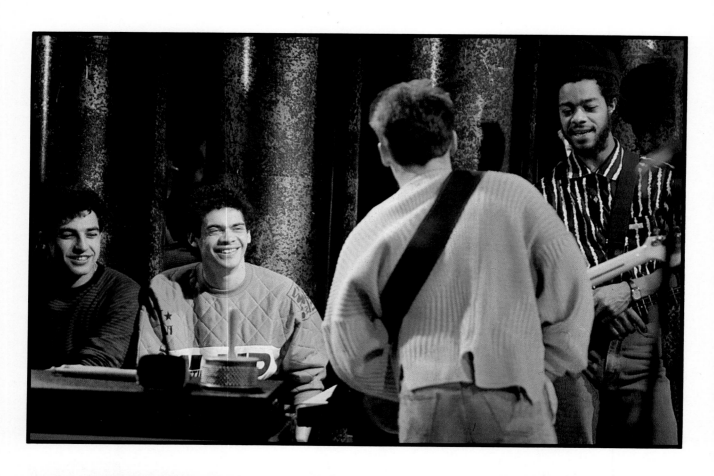

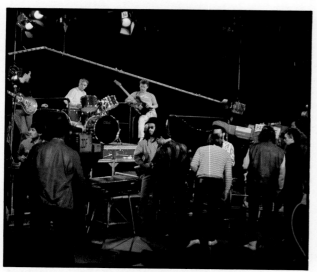

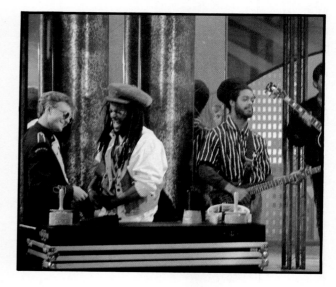

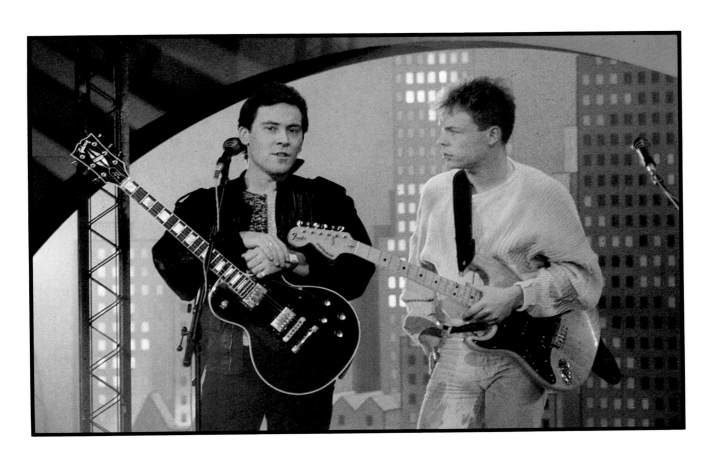

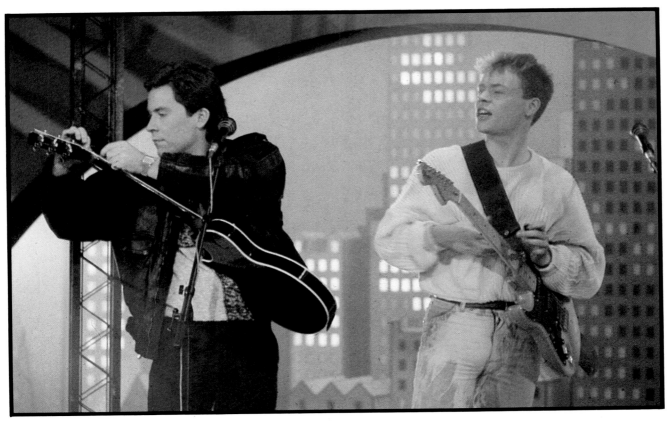

Management

We'll do a tour in order to promote our records. After all, the performance that most people hear most often is on record. You can't play regularly to all of the people who want to hear UB40's music. So most people hear UB40 on record and we tour to remind people of what the music is like and why it is worth having the record, and to make sure that they don't forget us.

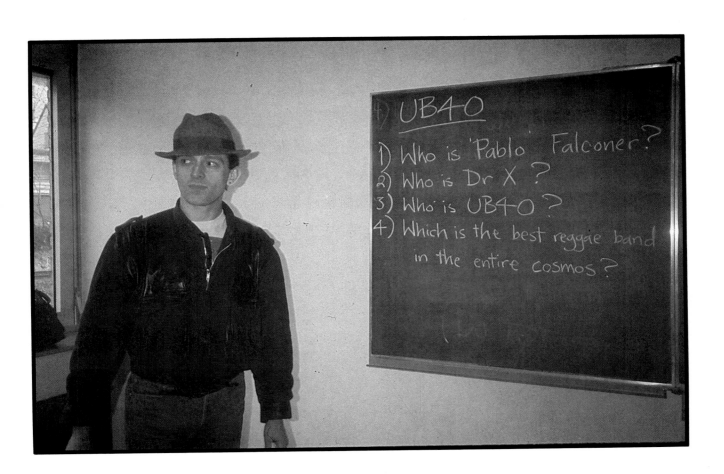

To mount a tour, first you decide what tour you want to do, where you want to go, how long you want to spend doing it. The band decides that. But once they have decided that they want to spend so long touring such and such territories, then it is a case of canvassing for offers from promoters in those territories and choosing the good offers in such a way that the tour can be routed sensibly so that you are not going out of a territory and you can do all your German dates in one go in Germany and move onto the next one and so on in the most economical way. So I suppose the first stage is discussion between me and the band and the tour manager to decide what the tour is going to be basically and what it hopes to achieve and what the restrictions are in terms of time and duration.

CCH Hamburg

Amsterdam

The second stage is the agent's work, where he lets the promoters in those territories know that UB40 are available for a particular period. He comes back to me with offers for various shows during that period and some negotiation goes on as to fee and conditions. He reports the acceptable offers to me and generally I will decide which of those offers we are interested in, give him any further instructions if it seems that any negotiation needs to take place and then he will come back to me with a whole tour plan proposal involving all of those dates, assuming that all these negotiations are followed through successfully. Then I take that tour plan to the band and they may make some objections. They may say that we don't need to play that many dates in that particular territory or, 'no we don't want to play that place'. 'We played there last time and it was a dump', or whatever. 'That's where we got arrested', or where the coaches got broken into. Reasons for not doing something. And then when they have had their opportunity to check it I put it back to the agents and say go.

Then the bookings are made and then Gus our tour manager comes into action, dealing with the promoters initially through the agent and then directly to make sure that everything is as it should be and that the venues have the necessary power supply and that they are basically sound professional, safe venues. While he is doing that he will be negotiating deals for transport of personnel and equipment and deals on hotels. A lot of it is to do with transport; train costs, ferry costs, flights, air freight. At the same time he will be talking to crew, offering the various jobs on the tour to the people we would most like to do them.

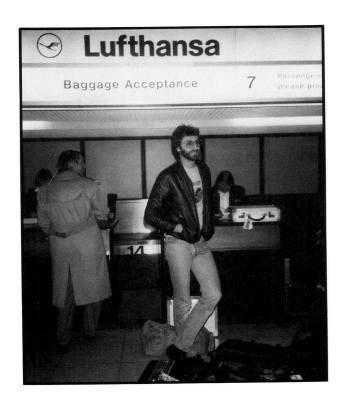

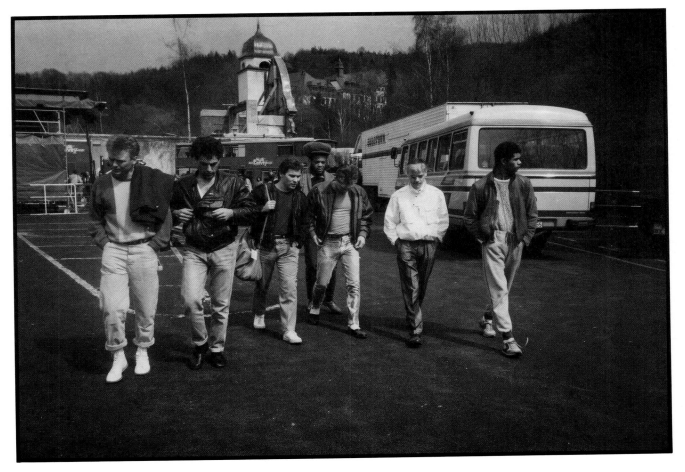

Everything that is not actually performing comes under Gus's regime. Gus is directly responsible to me and ultimately to the band for absolutely everything on the tour that is not performing. He is on the go the whole time making sure that things are still going to happen and that they are happening right. He is dealing with the promoters, he is dealing with venue managements, he is dealing with the crew, who are responsible to him. He just makes sure that the Tour happens as it should; that the band arrives when and where it should; that the crew arrive with plenty of time to rig the equipment. He gets both parties out of the scrapes that they can get into. Like getting held up at borders, or custom points, or vehicles breaking down. He has to oversee the whole Tour and be responsible for the whole party which is anything between eighteen and twenty-five people.

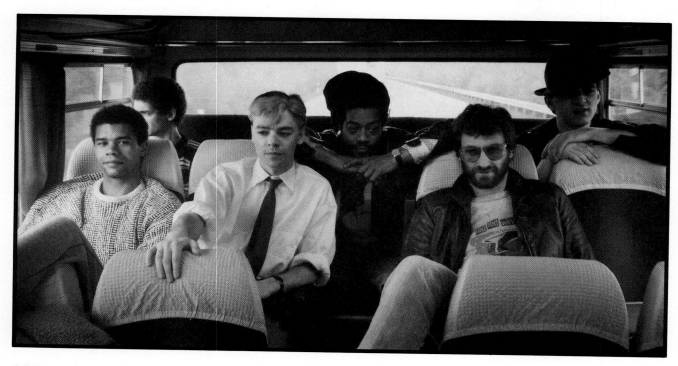

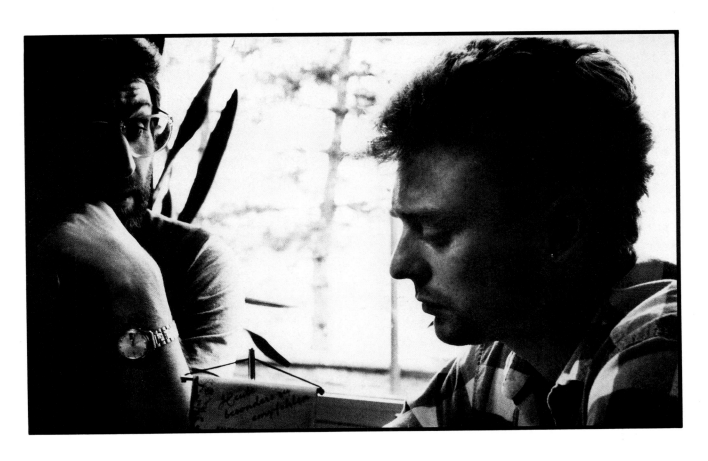

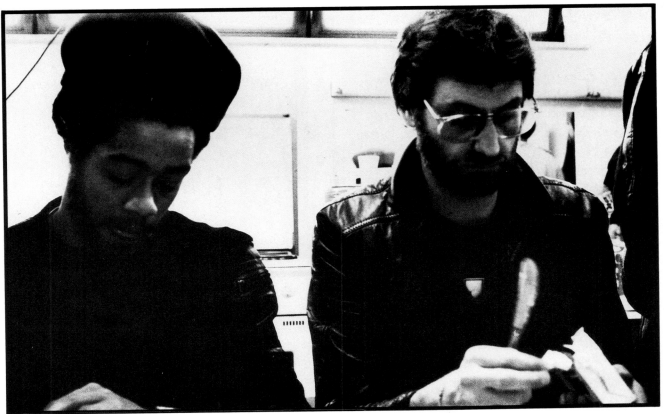

Generally speaking I don't make deals on tour. Usually if we are on the road that means the deal has been done because we would not be there if we did not have a record release. Also of course I am there as the ultimate authority in case of serious problems. Gus deals with serious problems every day without needing to refer to me but if it goes past a certain degree of seriousness, he will want, or may need to bring me in. I am an extra gun. I am the heavy artillery, if we have a disagreement with a promoter or wherever I judge that some extra or higher influence or persuasion is desirable. The band do not concern themselves with business any more than they can possibly help when they are on the road because it is enough for them to play every night. So on tour I won't consult them unless I absolutely have to.

A bad tour doesn't mean our losing money. We may lose money anyway and we do the tour for its promotional value. That's the basic purpose of touring and because we do not tour as much as a lot of other acts we have to expect losses; as long as the other people do not make losses. As long as the promoter is making money and the agent is making money and the record company is seeing active promotion on our part, then there is never any question about the fact that you are going back because everybody wants to make at least that much money again next year. I don't think it has ever arisen with us that we have left a territory feeling that we would not be welcome there again. That simply has not happened. We have never done a bad tour in that sense.

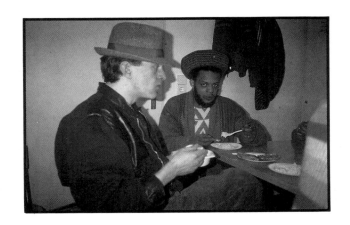

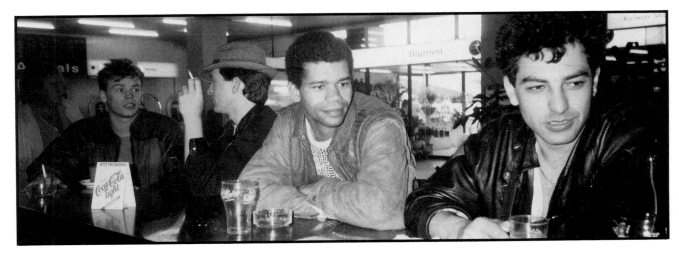

Incidents

There have been many incidents that we have all experienced whilst on the Road. They range from being in an Earthquake in Tokyo to being in a Bush fire in Australia. But even these will not put us off touring. Here are three examples, in our own words.

Hanover, Germany.
The Gun Incident *as told by Jimmy.*

The Zimbabwe Incident *as told by Robin.*

The Ibiza Incident *as told by Astro.*

Hanover

We were driving down the road in a bus and there was this group of about three geezers kicking this bloke who was lying on the floor. I mean they were really kicking him. So of course we all got out to the rescue and all this business and these blokes legged it and there was one geezer came walking up to the bloke lying on the floor and we thought he had come to help him and he bent down, lifting him up by the hair and started hitting his head against the pavement. So one of us went round and pushed this guy away and another one of our lot ran up and booted this guy in the face and he was on the floor and then these two other geezers came running back and one of them had a gun behind his back and Robin noticed that he had got the gun and said 'Come on we'd better leave, this is getting really out of hand'. So we backed on to the coach and went. We weren't going to hang around and get shot and we don't know what happened to the guy. They were killing him. He may well be dead but anyway we weren't going to argue against a gun. It's a freaky thing to happen to you, have a gun pulled on you.

Zimbabwe

There's things that happen to you on tour which are unbelievable. Like when we played in Zimbabwe. We took over ninety tons of equipment. We went to celebrate the second year of independence and we were the biggest thing that had been to Zimbabwe except for Marley, but we took a much bigger show. Zimbabwe had had a drought for four years and we stuck up our equipment on an open air stage in a cricket ground. This giant stage and everything, and they had a storm. If that's not ridiculous, I don't know what is. It hadn't rained for four years and they had a storm the night we stuck our gear up. So the show was cancelled. It was like being in a force nine gale. The canopy was blown over and was water-logged. There was a riot because they resented the fact that we would not come out and be electrocuted. Things like that are unbelievable. That you can actually go somewhere that hasn't had a drop of rain in four years, set up your gear and then the heavens open up. It was ludicrous.

Ibiza

We were doing 'Ibiza 80' with Eddy Grant. It was to take place in a bullring. Now the promoters had said, 'There's only one show - spend a week there, and do the show on the last night before you go home. Bring the wife, bring the kids...' So we brought everybody. 'We'll find all your food and accommodation,' they said, 'Don't worry about money.'

So we're just coming into Ibiza on this boat, and in the distance there are all these beautiful mountains, and there were these cranes sticking out. Just as a joke, somebody says, 'Oh, there's our

hotel.' And it was. Everybody's heard the stories about Spanish holidays. Beautiful hotel, half finished.

Everybody had beautiful apartments. Nice living-room area. Nice three-piece suite, TV, nice bedrooms. Beautiful kitchens, nice blue stone tiling. Beautiful gas cooker. No gas. Beautiful sink, bath, toilet. No water after ten o'clock. So if you went to the toilet after ten o'clock, you couldn't flush it. Beautiful swimming pool in the shape of a banana. They filled that the day we were leaving. We'd been staring at an empty pool all week.

Basically, it was still a building site. When we arrived there, the hotel manager must have rounded up a few locals. We saw them actually wheeling in the curtains and trying to stick them up in the rooms. Bringing in the beds and assembling them on the floor while we were standing there.

As we land, the guy's there to meet us. We're hungry, so he takes us to this really posh restaurant. Everybody's thinking this is a bit of all right, and ordering the most expensive thing on the menu. And the oldest trick in the book is about to be played. The waiter comes with the bill, and the guy's saying, 'Would you believe it, I've left my wallet in my other suit...' So poor Jimmy, he's the only one who's brought any bread, he's had to pay for everybody's meal. Now he's as broke as everybody else. We all had fifteen to twenty quid, to last a week.

All the time I was in Ibiza, the media latched onto me and, as far as they were concerned, regardless of what I wanted to tell them, I was Eddy Grant. We went out to a night club, and some local photographer was taking snaps like crazy. I'm just sitting there, flash bulbs going like mad. The following morning I've woken up and seen me in the paper as Edward Grant out on the town

Simon (our manager, then) went and told Eddy Grant what had gone on, and suggested they talk to the promoters about all the promises they'd broken so far.

Eddy Grant didn't care. He was being treated like a lord. He had a villa to himself. Anything he wanted, no sweat. His band were in a worse state than we were, but his attitude was that we should just do the show and sort out the problems afterwards.

Then comes the night of the show, and we've had just about enough. It had come to the stage where the kids were starving because we had no money, and had to wait until five-thirty in the afternoon for this one hotel to have its siesta, then for about thirty bob you could stuff yourself rigid. We decide we're going on stage only when we see some readies. Simon was talking to the promoters for ages, then came back and said, 'Whatever you do, don't go on stage until you see me come back.' So Simon's gone back to do battle. He's screaming at them and they're screaming at him.

While Simon's away, people keep coming around, chatting about anything and everything. After they'd given you a good smoke and thought you were well-oiled, they'd say, 'Ready to do the show, then?' Then somebody else would come along and do the same thing, and try to slip it in more casually. Meanwhile, the police have been called, and we're told we're going to be

arrested for incitement to riot and causing a disturbance, by not doing the show at the time specified on the tickets. We were about to be arrested, when Simon came back holding this briefcase to his chest. 'Right,' he says, 'I've got the money.' And he had to come on stage with us, so that the money didn't make its way back to the promoters. They had to pay us, and they hadn't sold as many tickets as they were expecting. They didn't have enough money to pay Eddy Grant, but Eddy didn't know this.

So we've done our set and Simon's been there the whole time at the side of the stage. We came off, Simon with us, back to the dressing room, and discovered that Eddy Grant had refused to go on until he had seen his money. The police arrested him, locked him and his band away, and impounded our equipment. Also, it turned out that the promoters' money had come from shady deals. So we decide we've got to get this money out of the building and back to safety.

Simon was freaking because he isn't very physical, and if anybody tried to get it off him, he knew they'd succeed. So I was delegated to take the bread back to the hotel, along with Simon's girlfriend, Den. The two of us and Norman are standing in this taxi queue about fifty yards long, and I'm wondering why the hell I was chosen, when everybody already thinks I'm Eddy Grant - now here I am, standing in full view just around the corner from the show, and all these disappointed people are saying, 'Eddy, why didn't you play?' And I'm trying to be inconspicuous with this bread. And there's this bloke standing in front of us,

who's trying to get me into conversation. He started off giving the impression that he was just a tourist, and then said that he was a d.j. on a local radio station. He was moving towards Den, who'd actually got the briefcase, and me and Norman were boxing him in from either side. Suddenly, a taxi comes along, and a guy who was sitting on a bench nearby jumps straight in ahead of the queue. The guy who's talking to us legs it into the taxi with the other guy. He didn't try to snatch the money. It was just so weird.

When we got back to the hotel, we thought there'd be some real heavies after the money. Being half way up the mountain, we could see for miles down the only road. As I say, it's a building site, and Norman and I have got rubble - housebricks and blocks of wood - we're we're armed to the teeth and hiding behind these bricks, watching. Two cars came up, but they drove straight on, and the next thing we knew, the rest of the band turned up.

That was it. We managed to escape from Ibiza. Never again.

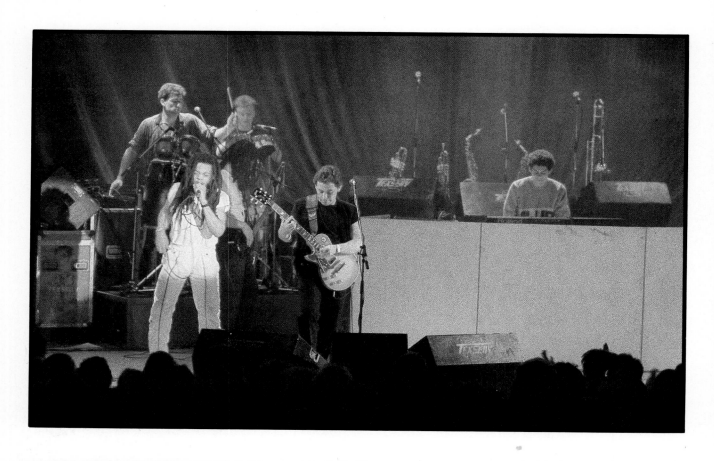

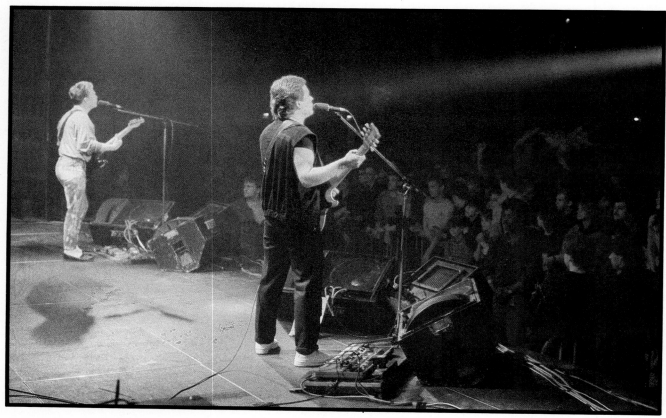

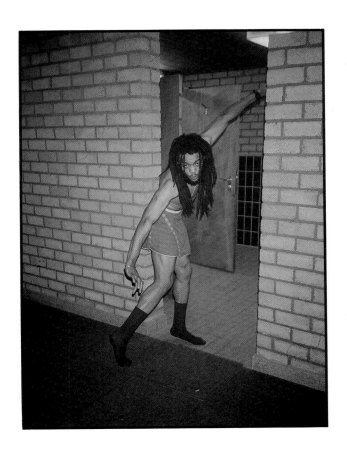

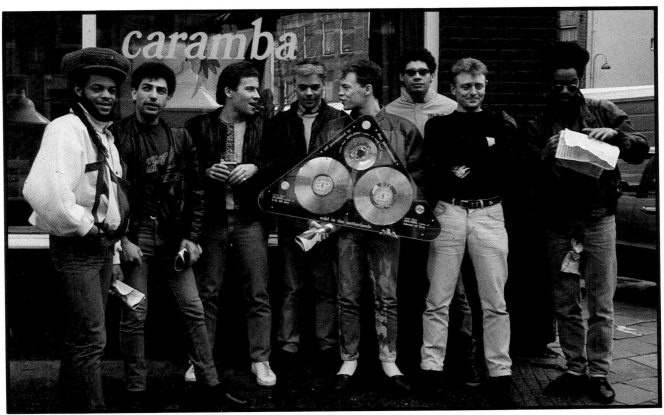

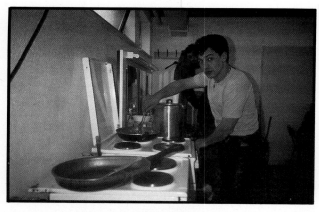

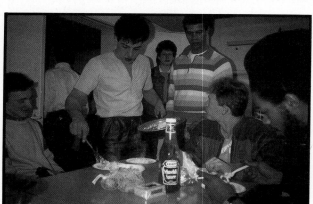

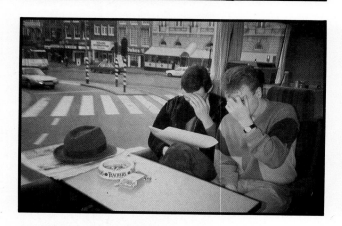

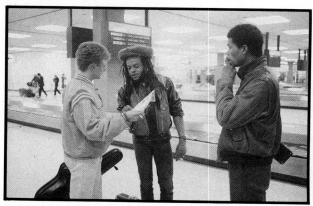 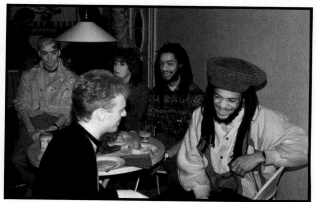

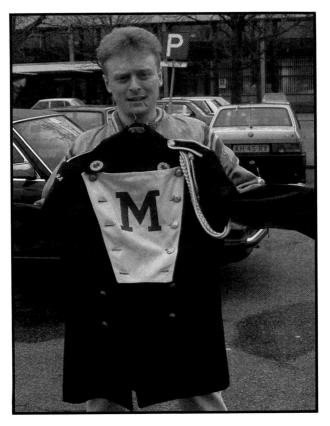

List of Personnel

James Brown	Drums
Earl Falconer	Bass Guitar
Robin Campbell	Guitar/Vocals
Ali Campbell	Vocals/Guitar
Michael Virtue	Keyboard
Brian Travers	Saxophones
Norman Hassan	Percussion/Trombone/Vocals
Astro	Trumpet/Toasting
Ray Falconer	Sound Engineer
Gus Douglas	Tour Manager
Anthony Bradbury (Animal)	Backline/Roadie
Dee Taylor	Backline/Roadie
Nimmo Singh	Backline/Roadie
Lloyd McPherson	Backline/Roadie
Peter Currier	Lighting
Adrian Finn (Drain)	Lighting
Steve Rusling (Stoner)	Lighting
Steven Smith (Gonzo)	Monitors
Pete Shepherd	P.A.
Barry Hay	P.A.
Nigel Hudson	Truck Driver
Ken Watts	Truck Driver
Graham Gower	Coach Driver
Ricky Brown	Coach Driver
Dave Campbell	Manager
Paul Davies	Financial Director
Robyn Carter	Promotions
Clive Lichfield	Prod. Manager
Peter Walmsley	Merchandise
Faith Isiakpere	Photographer
Jim Rowland	Photographer

Faith Isiakpere

Jim Rowland

For extra copies of this book and for all UB40 merchandise and information, please contact:

P.O. Box 117
Birmingham B55 RJ